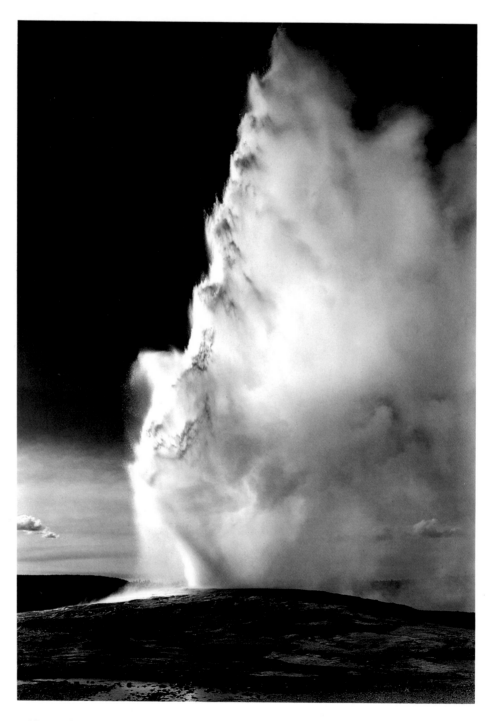

Old Faithful Geyser, Yellowstone National Park, Wyoming, 1942

ANSEL ADAMS
Our National Parks

Edited by Andrea G. Stillman and William A. Turnage

Little, Brown and Company

Boston • Toronto • London

First Edition

Library of Congress Cataloging-in-Publication Data
Ansel Adams 1902–1984
Ansel Adams, our national parks / edited by
William A. Turnage and Andrea G. Stillman. — 1st ed.
p. cm.
ISBN 0-8212-1910-3
1. National parks and reserves — United States — Picto-
rial works. 2. United States — Description and travel —
Views. 3. Photography — United States — Landscapes. I.
Turnage, William A. II. Stillman, Andrea Gray. III. Title.
E160.A295 1992
770'.92 — dc20 91-38323

Cover illustrations:
Front: The Tetons and the Snake River, Grand Teton
National Park, Wyoming, 1942
Back: Ansel Adams, c. 1930 (by Cedric Wright)

Published simultaneously in Canada by
Little, Brown & Company (Canada) Limited

Designed by Sametz Blackstone Associates
Imagesetting in Monotype Bembo by Graphics Express
Printed and bound by Amilcare Pizzi, Milan, Italy

One of the greatest satisfactions in working on this book
is the opportunity it provides to thank the many people
who helped make it possible: Virginia Adams,
Janet Swan Bush, Pam Feld, Amanda Wicks Freymann,
Terry Hackford, George Hall, John Kane, Jeff Nixon,
Antonis Ricos, John Sexton, Theodor Swem,
and Ron Tipton.

A.G.S. & W.T.

Parks and Monuments Included in *Our National Parks*

For selected writings by Ansel Adams about our national parks see pages 15–18 and pages 112–127.

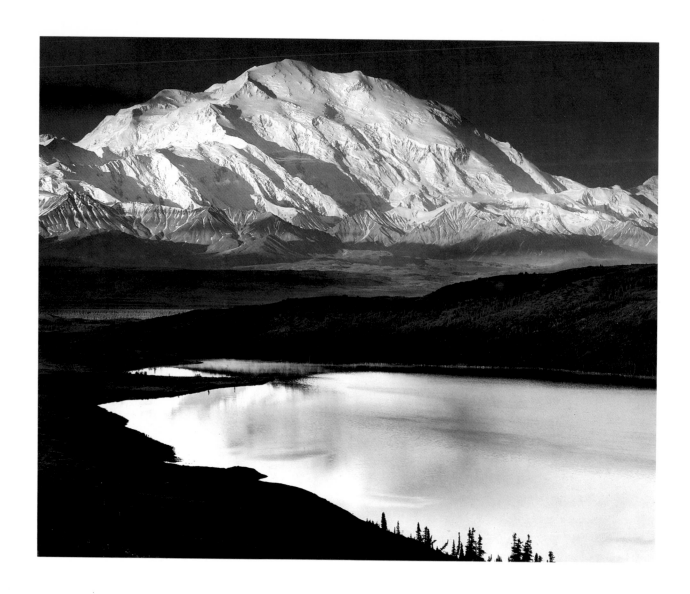

Mount McKinley and Wonder Lake, Denali National Park, Alaska, 1948

Preface

William A. Turnage

In the century and more since the establishment of the world's first national park, in Yellowstone, it is unlikely that any individual has rivaled the quantity and quality of photographs and writings by Ansel Adams, made in his unceasing effort to support the philosophical essence and practical evolution of this uniquely American concept. Beginning in the 1920s and continuing almost without a single day's interruption until his death, in 1984, Adams was the most ardent champion — in words and images — of the "national park idea." He was, at the same time, arguably the Park Service's most frequent, informed, and constructive critic.

Adams spent a significant part of his adult life in Yosemite National Park. He visited and photographed in virtually every unit of the park system (as it existed in mid-century). He took many thousands of photographs, some of them among the most memorable images of the natural scene ever created. He produced two dozen books and portfolios interpreting one or more parks, he wrote and often illustrated scores of articles, essays, and reviews, and he created hundreds upon hundreds of photographic exhibitions. Quite literally, he brought the parks to millions of Americans who had never actually visited one of these great American cathedrals. His work helped to create new parks and better protect existing parks. It also served to expand the popularity of the parks and, ironically, thereby added to the subsequent burdens of ever-increasing visitation.

Adams, above all, believed in communication and persuasion — and communicate he did. In addition to making myriad legendary photographs of the parks, he crisscrossed the U.S., giving talks about the park idea to small and large environmental gatherings, to students in colleges, to the public at large. He wrote literally thousands of powerfully informed letters to Park Service leaders and staff, to fellow-environmentalists, to Presidents and cabinet officers, to newspaper editors, journalists, and scholars — in short, to anyone who would listen.

In these letters, Adams exhorted, suggested, inspired, implored, scolded — but was unfailingly cordial, no matter how intense the debate or disagreement. His letters were always interesting, often brilliant, containing insights and analyses that were frequently unique — sometimes startlingly so. He was remorseless in his insistence on a higher standard of care for nature and concern for the spiritual-emotional aspects of the visitor experience. He covered every topic imaginable in the realm of park management, from resource protection to limitation of visitor numbers, from concessions to Park Service leadership, from souvenir standards to park signage, from the semantics of parks, reserves, and preserves to park interpretation, and more.

This immense passion for parks and wilderness began on the then remote and uncrowded sand dunes of San Francisco's Golden Gate. The Adams family home overlooked the magnificent opening to the Pacific and the wild Marin Headlands, today the heart of Golden Gate National Recreation Area — an idea originated by Adams himself in a series of letters in 1954. Born four years before the Great Earthquake of 1906, and weaned on the quiet creeks, small woods, wild dunes, and sparkling beaches of this westernmost reach of the American continent, Adams became, in his words, a "nature boy" before the city grew westward to the ocean. By the time he was fourteen, his attention was turning toward the "range of light," California's Sierra Nevada, and its mighty heart, the Valley of the Yosemite. He first visited Yosemite that summer, just two years after the death of John Muir, and only a few months before the National Park Service was founded by Stephen T. Mather. As he was later to write, "From that day in 1916, my life has been colored and modulated by the great earth-gesture of the Sierra."

Adams' lifelong relationship with Yosemite National Park was intimately bound up with both his photography and his close association of more than a half-century with the Sierra Club. The Club had been founded by Muir in 1892 in order to fight for the establishment and expansion of Yosemite as a national (rather than state) park. In 1920, Adams became summer custodian of the Club's Yosemite Valley headquarters, LeConte Memorial Lodge. He led daily interpretive hikes, gave maps and information to visitors, and assisted Sierra Club members. In 1921, he made the first of many, many trips into the Yosemite High Country. By 1924, he was accompanying Sierra Club friends on pack trips into remote and relatively uncharted parts of the Sierra. He also made his first important photographs in this period and began to publish both images and writings in the *Sierra Club Bulletin*. In 1934, Adams was elected to the Sierra Club board of directors and played a leadership role in the organization until the early 1970s.

Adams spent time in Yosemite and the High Sierra for sixty-seven consecutive years. Nothing save death could end the relationship with his beloved Range of Light, and then only corporeally. The symbiosis between Adams and Yosemite, man and place, art and environment, perception and reality is perhaps unparalleled in American history and continues in his photographs and writings — indeed, in this book, as in so many others.

The 1930s witnessed Adams' swift rise to a leading place among American creative photographers. There were important exhibitions and critical museum projects in the East, his first books, as well as fruitful lobbying work in Washington, D.C., as part of the Sierra Club effort to protect the Kings River Sierra in a national park. In 1941, Interior Secretary Harold Ickes asked Adams to become "photomuralist" for the department and launch a long-term project to photograph the entire park system. Unfortunately, this exciting concept had been barely initiated when it was canceled by American involvement in World War II. After the war, Adams received a series of Guggenheim Fellowships, which enabled him to undertake the park system project on his own. Though he never made a photograph for a specific conservation purpose, he believed that the expression of beauty in nature was argument in and of itself. "I begin with the primal aspects of the world, and I end just where the naturalist takes over. The grand landscapes and the blades of grass appear with equal eloquence. . . ."

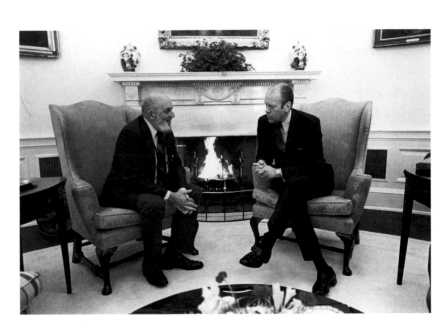

With President Ford at the White House (by Ricardo Thomas, 1975; courtesy the Gerald R. Ford Library)

Adams visited most of the units of the system as it then existed, often tramping the backcountry, sometimes with horses or mules to carry cameras and supplies, sometimes on foot. In Alaska, a land virtually without roads, most of his travel was by boat or seaplane or bush plane. Many of his famous parks photographs were made from the large platform mounted atop his rugged old Cadillac. As Nancy Newhall, his collaborator on so many parks projects, wrote in *The Eloquent Light*:

If you work with Ansel Adams, you get up before dawn. Maybe you wake in a sleeping bag on the edge of a canyon, with immensity at your elbow, or in a ghostly shimmer of cholla cactus, under the monstrous columns and candelabra of saguaros. Maybe what wakes you is the fume and sizzle of steaks frying, or coffee, handed you scalding in a hot tin cup with cool wire handles and SIERRA CLUB stamped in the bottom. But if the stars are paling and the rim of the world is already visible, the bray of a donkey or the yap of a coyote, rendered with heart-breaking and ear-splitting accuracy [by Adams], will bring you up standing. . . .

Adams is an automobile hypochondriac, and with reason, for the loads he must ask a car to carry across deserts and dry washes, up mountains and through snow, and often cross-country without benefit of road, are appalling. What with cameras, film, lenses, food, sleeping bags, clothes, waterjug, whisky, extra gasoline, pickax, crowbar, rope, and people the weight is punishing. And something as slight mechanically as a flat tire could mean disaster.

Much more often, however, there is a happy caper on the rim, and Adams comes pelting back. "Yipe! Going to be just beautiful out there in a couple of minutes." Down from the roof, where they have been rattling rhythmically for miles, come the tripods, to be set up in a flash. Out from the back seat come the cameras, each in its case painted white for coolness.

Up on its tripod goes his largest camera, the 8 x 10, a special duralumin model he got from an Arctic explorer, or the 5 x 7 Sinar, perhaps his favorite at the moment. Out of their flannel bags come the lenses. All good photographers are fast, but Adams is so fast it looks like sleight-of-hand. If the site is still some distance away, he shoulders the most important camera and the heaviest film case, while you, if you are the only lug available, follow behind like a prospector's burro, strung with meters, small cameras, filter book, notebook, gray card, Hasselblad. . . .

Adams' parks philosophy was rooted in his deep belief that nature and beauty, particularly as symbolized by wildness, were essential elements of the human soul. The intensity of this concept can be

comprehended only by spending time with his photographs, as it is not something expressible in words. Adams' images, primarily done in black and white, were intended as emotional statements, "the equivalents" of his feelings, and clearly departed from — indeed, *enhanced* — reality. His passion for wilderness was his substitute for a belief in God and organized religion. He imbued nature with quasireligious powers, much in the mold of his intellectual forefathers Thoreau and Muir. Throughout his life, he sought to persuade one and all — and most particularly, the often recalcitrant officials of the National Park Service — that the true park experience was internal, subtle, emotional, and related to essentially mystical human reactions to the natural world.

In the 1950s and 1960s, Adams became a national figure, both as artist and environmentalist, and his influence and his circle of correspondents increased apace. In conservation as in photography, his primary focus was always nature in its untrammeled form — national parks and wilderness. Adams maintained frequent communication with every Park Service director after Mather; and with the most effective and imaginative directors, Horace Albright, Newton Drury, and George Hartzog, he was on particularly close personal terms. He was in regular contact with Interior secretaries, senators, and other leading public figures. He was the only environmental advocate with easy access to the President. In meetings with political leaders, a curious sort of role reversal took place, with the political ego standing aside in deference to the sense that here was a man who sought nothing for himself, only good for his country.

Despite the great respect he engendered — and the lasting impact his work had in creating and deepening support for wilderness and the park idea — much of Adams' efforts with regard to parks policy and management were, in the end, unsuccessful. Most of the key issues for which he crusaded for decades are still, today, the key issues facing the national parks: the pro-development tendencies of the Park Service itself; the resortism and economic self-seeking of the park concessionaires; the lack of imagination and bold leadership at the national political level; the failure to comprehend the essential importance of mood and emotion in the human relationship to wildness; the difficult problem of encouraging appropriate use without overwhelming the resource.

But Adams never gave up and never lost sight of the "high horizon." He wrote a close Sierra Club colleague, in 1954, "I am frankly, and perpetually, an evangelist. I hate compromise (which is quite impossible in the domain of the spirit). And I am quite unhappy in the face of lack-of-courage." In October 1944, Newton Drury, the most environmentally oriented of all Park Service directors,

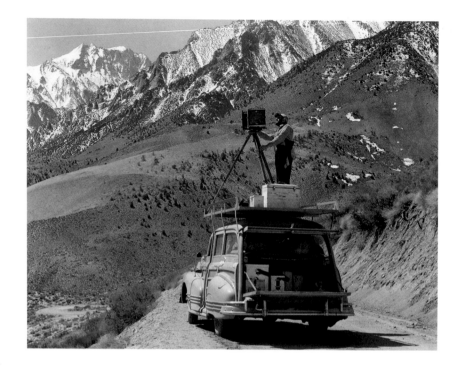

Ansel Adams photographing
from the top of his station wagon,
east side of the Sierra, California,
c. 1949 (by Cedric Wright)

wrote to ask Adams not to be discouraged and to keep pushing the Park Service to address the basic issues,

In an organization like this, short-handed as we are and with all the exceptional episodes that have to be dealt with, we are inclined to devote a disproportionate amount of time to the mechanics of our business and a minimum to the fundamentals, which deal many times with intangibles. It is good, therefore, that there are thinkers who periodically call us back to consideration of the matters of prime importance.

This book seeks to present a selection of Adams' finest national parks photographs and a modest sampling of his ideas, as presented in letters, articles, memoranda, and speeches. The images are as fresh, powerful, and important today as when they were made, in some cases as long ago as fifty years. Much the same can be said for Adams' writings and speeches. It is our hope that the

combination will enable you to take a deeper look at your national parks and what they mean to you, to our nation, and to our world. Adams himself put it best in a "personal statement" prefacing his first book about the park system (*My Camera in the National Parks*, 1950):

In terms of creative photography [my work] may be considered an Introduction to the National Parks and Scenic Monuments. It relates more to photography in *than* of *the areas so designated. The grandeurs and intimacies of Nature as presented here will, I hope, encourage the spectator to seek for himself the inexhaustible sources of beauty in the natural world about him. Fortunate he is, indeed, to see Mount McKinley against the summer midnight sky, the lush fern forests of Kilauea, the white jubilance of Yosemite's waters, and the somber Atlantic rock and surf of Acadia. But perhaps in his own garden — even in a flower pot on a window sill — a single leaf turned to the sun will hint of the revelations of Nature so grandly expressed in the domains of the National Parks. To record and interpret these qualities for others, to brighten the drab moods of cities, and build high horizons of the spirit on the edge of plain and desert — these are some of the many obligations of art.*

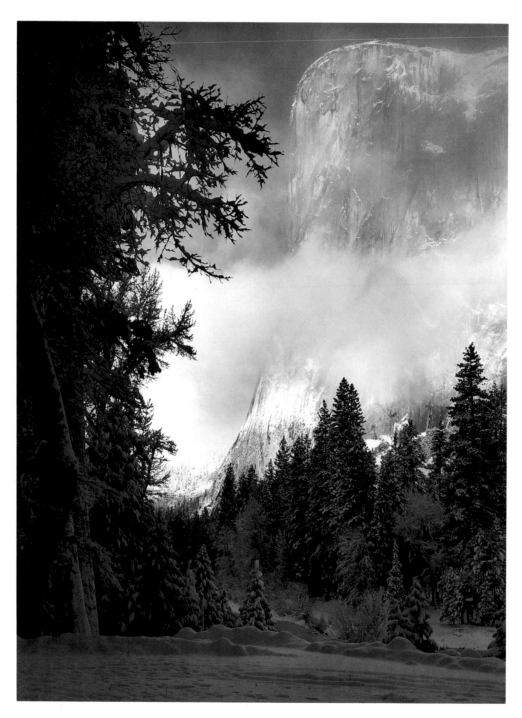

El Capitan, Winter, Sunrise, Yosemite National Park, California, 1968

The Meaning of the National Parks

Ansel Adams

The National Parks, are, indeed, phenomena of an advanced society; James Bryce once said that the concept of the National Parks was America's unique contribution to the democratic idea. In fact it is difficult to conceive of America without them; one-fifth of our people experience the National Parks and Monuments within a single year. Nevertheless some confusion exists within the public mind as to what the National Parks are, why they were established, and how they differ one from another. We are constantly seeking a satisfactory definition of the Parks which embraces the factual, administrative, and intangible objectives; such a definition must be both positive and fluid, yet never deviate from a clear, idealistic focus.

We have been given the earth to live upon and enjoy. We have come up from the caves; predatory and primitive ages drift behind us. With almost the suddenness of a Nova's burst to glory we have entered a new dimension of thought and awareness of Nature. The earth promises to be more than a battle-field or hunting-ground; we dream of the time when it shall house one great family of co-operative beings. At least we have the promise of such a world even if the events of our immediate time suggest a return to tooth and claw. We hold the future in a delicate and precarious grasp, as one might draw a shimmering ephemerid from the clutches of a web. The heritage of the earth, direct or synthetic, provides us with physical life. We have, in part, mastered its resources and believe we are able to extract therefrom what is required for millenniums to come without exhaustion of the source. We are now sufficiently advanced to consider resources other than materialistic, but they are tenuous, intangible, and vulnerable to misapplication. They are, in fact, the symbols of

This essay first appeared in My Camera in the National Parks *by Ansel Adams, published in 1950 by Virginia Adams and Houghton Mifflin Company.*

spiritual life — a vast impersonal pantheism — transcending the confused myths and prescriptions that are presumed to clarify ethical and moral conduct. The clear realities of Nature seen with the inner eye of the spirit reveal the ultimate echo of God.

One hundred years ago the larger part of our nonagrarian land was a complete wilderness. Miners were just penetrating the foothills of the Sierra Nevada; hunters, trappers, and explorers had combed the mountains, plains, and backwoods of the continent but had left little permanent impression on the more comely features of the land. True, vast forests had fallen before the axe and plough, and wildlife was sorely depleted. Myriad buffalo bones bleached on the great plains, hides and pelts piled into the millions, the oceans were drained of the leviathans. These human invasions were as a great wind, wreaking certain havoc, but permitting certain revivals. Machines had but slightly supplemented hands. Man lived close to Nature — a raw and uncompromising Nature — and he was a part of the great pageant of sun, storms, and disasters. By the turn of the century the Nation came into its adult strength, industrialization had launched its triumphant final campaign, and men turned upon the land and its resources with blind disregard for the logic of ordered use, or for the obligations of an ordered future. The evidence is painfully clear; entire domains of the Pacific Northwest — once glorious forests — are now desolate brushy slopes. Thousands of square miles of the Southwest, once laced with green-bordered streams prudently secured by the groundcover of ample grass, are now a dusty phalanx of desert hills, starving the pitiful sheep and their shepherds that wander over them. We all know the tragedy of the dustbowls, the cruel unforgivable erosions of the soil, the depletion of fish and game, and the shrinking of the noble forests. And we know that such catastrophes shrivel the spirit of the people.

Possessions, both material and spiritual, are appreciated most when we find ourselves in peril of losing them. The National Forests were established just in time to prevent unimaginable disaster. Through the far-seeing efforts of men such as John Muir and Stephen Mather the concept of the National Parks was solidified and vast areas set aside *in perpetuum* against the ravages of diverse forms of exploitation. Then, through the device of Presidential Proclamation authorized by the Antiquities Act, many National Monuments of exceptional worth and interest were added to the growing system of conserved areas. Add to this the belated controls of other natural resources, and we cannot feel altogether planless and drifting — although almost every protective regulation was effected too late to achieve the ideal measure of success.

We hold little anxiety that the strictly utilitarian controls on forests, oil, mines, and fisheries will be seriously relaxed under our present concept of Government. These relate to our basic material security; every phase of our national life depends directly or indirectly upon these administrative controls. But the National Parks represent those intangible values which cannot be turned directly to profit or material advantage, and it requires integrity of vision and purpose to consider such impalpable qualities on the same effective level as material resources. Yet everyone must realize that the continued existence of the National Parks and all they represent depends upon awareness of the importance of these basic values. The pressures of a growing population, self-interest, and shortness of vision are now the greatest enemies of the National Park idea. The perspectives of history are discounted and the wilderness coveted and invaded to provide more water, more grazing land, more minerals, and more inappropriate recreation. These invasions are rationalized on the basis of "necessity." And this necessity may appear quite plausible on casual examination. People must have land, and land must have water. Cattle and sheep must have forage. With the establishment of reservoirs — great man-made lakes often reaching far into the wilderness domain — come diverse human enterprises, roads, resorts, settlements. The wilderness is pushed back; man is everywhere. Solitude, so vital to the individual man, is almost nowhere. Certain values are realized; others destroyed. The dragons of demand have been kept at snarling distance by the St. Georges of conservation, but the menace remains. Only education can enlighten our people — education, and its accompanying interpretation, and the seeking of resonances of understanding in the contemplation of Nature.

The great wilderness areas, designated for perpetuation of the intangible qualities of Nature, must be given appropriate use and interpretation, and complete protection. Perhaps one of the most positive ways of achieving this objective is to encourage writers, artists and photographers to utilize these profoundly beautiful areas as sources of inspiration and interpretation to the fullest possible extent. It is necessary to penetrate the illusion of mere "scenery" to achieve a more profound understanding of the world about us.

The development of our American society has favored the emergence of truly indigenous art. Great essayists and poets — Melville, Thoreau, Emerson, and Whitman — the last striking the great acrid bell of truth in his songs of praise of Nature and of Man; painters and photographers — Ryder, Winslow Homer, Thomas Moran, John Marin — Brady, O'Sullivan, Stieglitz, Edward Weston; and musicians — MacDowell, Copland, Bacon, the folksongsters, and many other adopted and native

composers and performers, have contributed mightily to the national life and spirit. If the domains both of Nature and of art have strongly influenced our culture, why can we not now bring them into more definite association? In those larger National Parks where thousands are drawn for spiritual experience, but who perhaps are distracted by dominating resort activities, we should present with appropriate restraint the greater works of music and art — if only to re-enforce and clarify the complex response to the natural scene. In my own experience here in Yosemite I find that there are many who approach the opportunity of hearing great music with almost religious devotion, for there is always great magic in the mingling of the emotional experiences of Nature and the aesthetic experiences of art.

Our time is short, and the future terrifyingly long. Believing as we must that things of the heart and mind are most enduring, this is the opportunity to apply art as a potent instrument of revelation, expression, and perpetuation of wilderness actualities and moods. Through art of brush, pen, and lens, each one no less than another, we possess a swift and sure means of touching the conscience and clearing the vision.

The dawn wind in the High Sierra is not just a passage of cool air through forest conifers, but within the labyrinth of human consciousness becomes a stirring of some world-magic of most delicate persuasion. The grand lift of the Tetons is more than a mechanistic fold and faulting of the earth's crust; it becomes a primal gesture of the earth beneath a greater sky. And on the ancient Acadian coast an even more ancient Atlantic surge disputes the granite headlands with more than the slow, crumbling erosion of the sea. Here are forces familiar with the æons of creation, and with the æons of the ending of the world.

In contemplation of the eternal incarnations of the spirit which vibrate in every mountain, leaf, and particle of earth, in every cloud, stone, and flash of sunlight, we make new discoveries on the planes of ethical and humane discernment, approaching THE NEW SOCIETY AT LAST, PROPORTIONATE TO NATURE.

Our National Parks

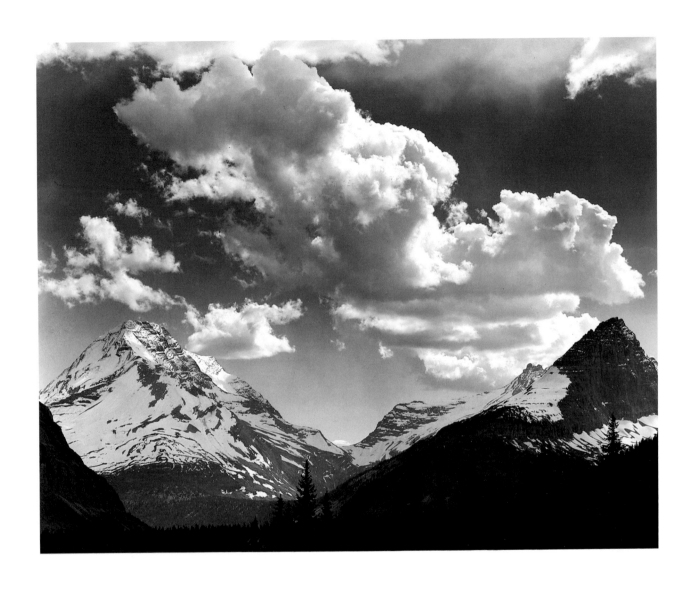

Noon Clouds, Mount Jackson and Mount Fusilade, Glacier National Park, Montana, 1942

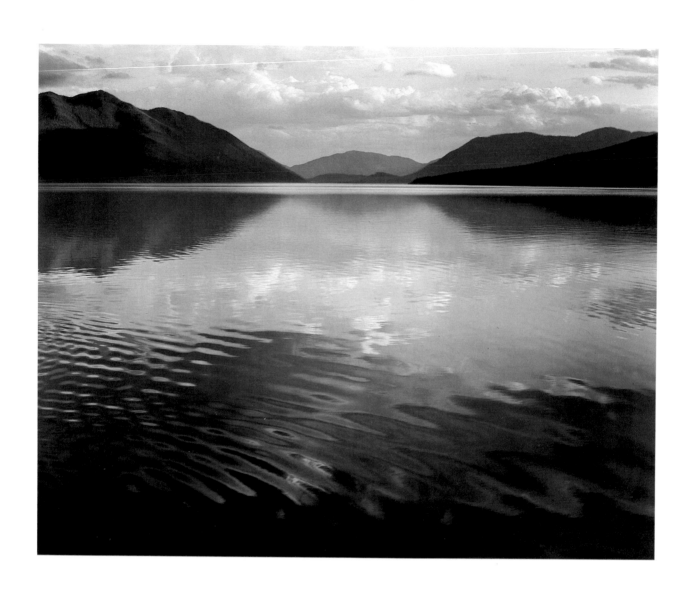

Lake MacDonald, Evening, Glacier National Park, Montana, 1942

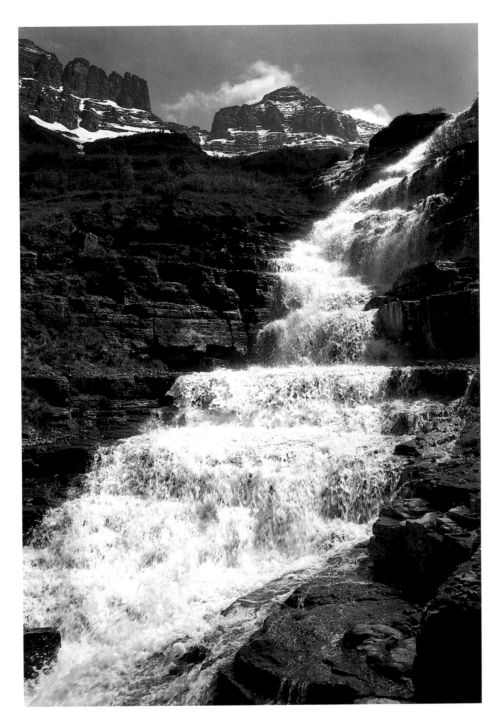

Cascade, Glacier National Park, Montana, 1942

I believe the approach of the artist and the approach of the environmentalist are fairly close in that both are, to a rather impressive degree, concerned with the "affirmation of life." . . . Response to natural beauty is one of the foundations of the environmental movement.

From "The Role of the Artist in Conservation,"
the Horace M. Albright Conservation Lecture, 1975

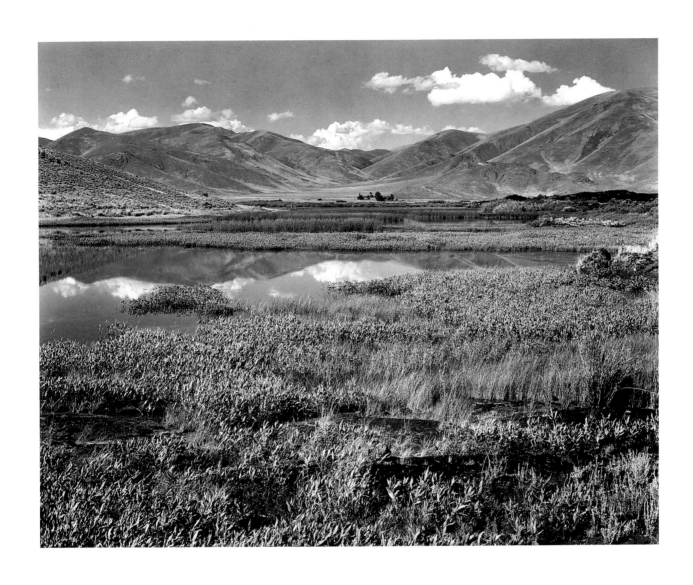

Lake and Hills near Craters of the Moon National Monument, Idaho, 1948

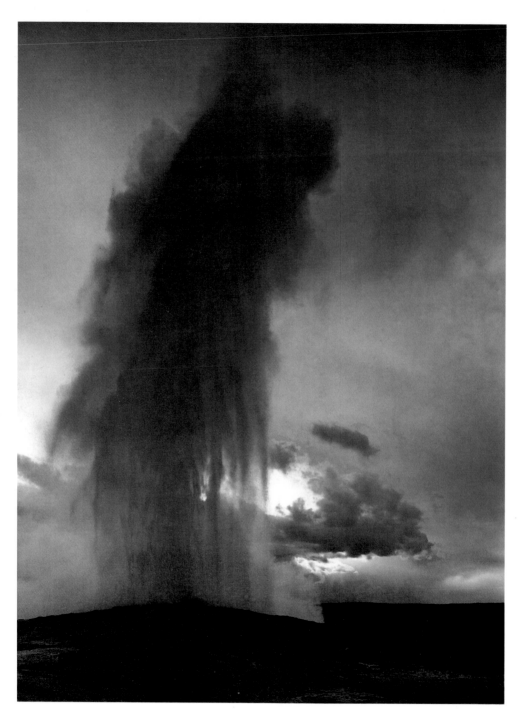

Old Faithful Geyser, Yellowstone National Park, Wyoming, 1942

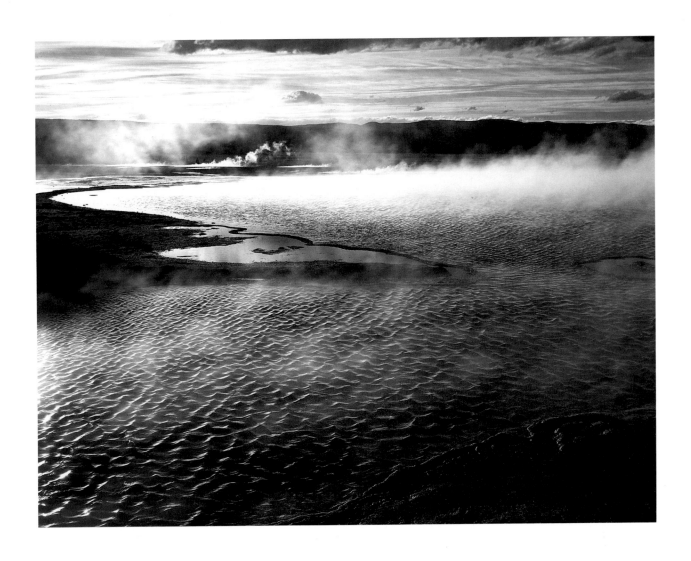

Grand Prismatic Spring, Yellowstone National Park, Wyoming, 1942

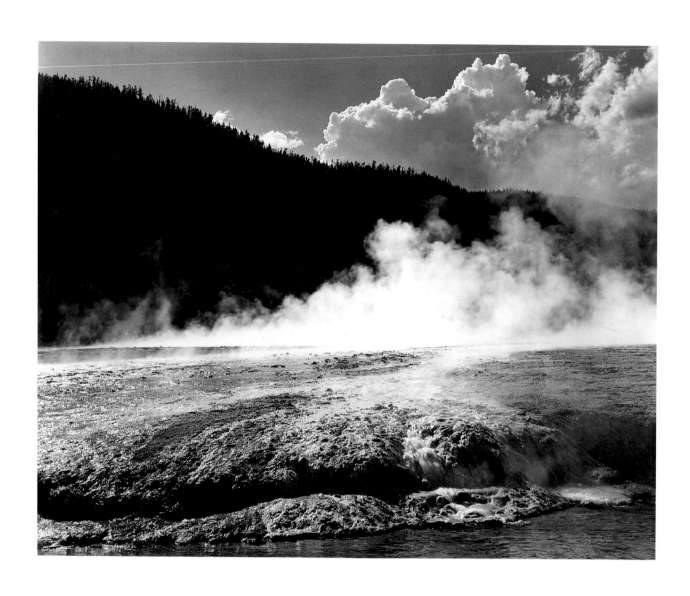

Firehole River, Yellowstone National Park, Wyoming, 1942

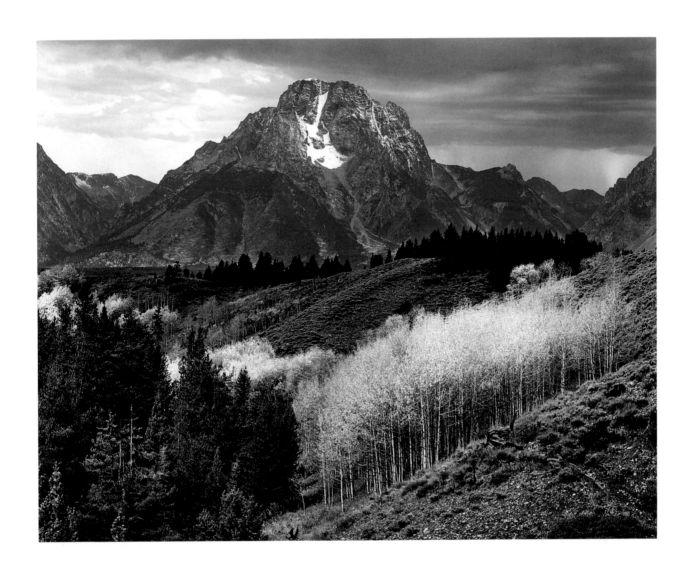

Mount Moran, Autumn, Grand Teton National Park, Wyoming, 1948

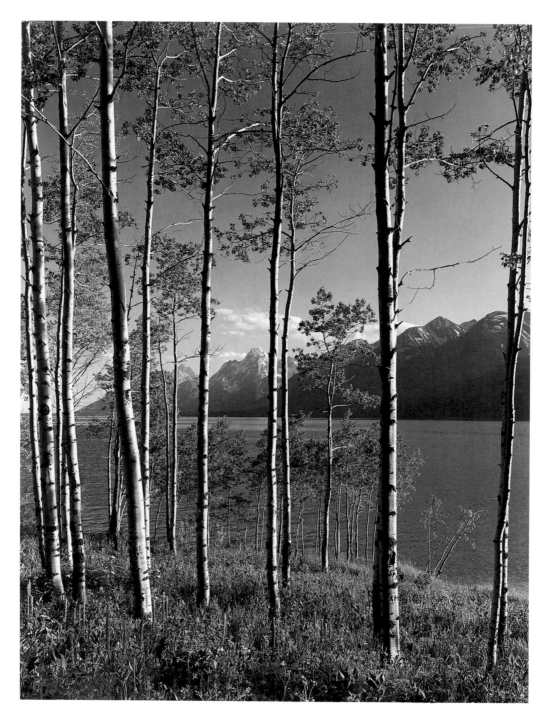

Aspen Grove, Jackson Lake, Grand Teton National Park, Wyoming, c. 1948

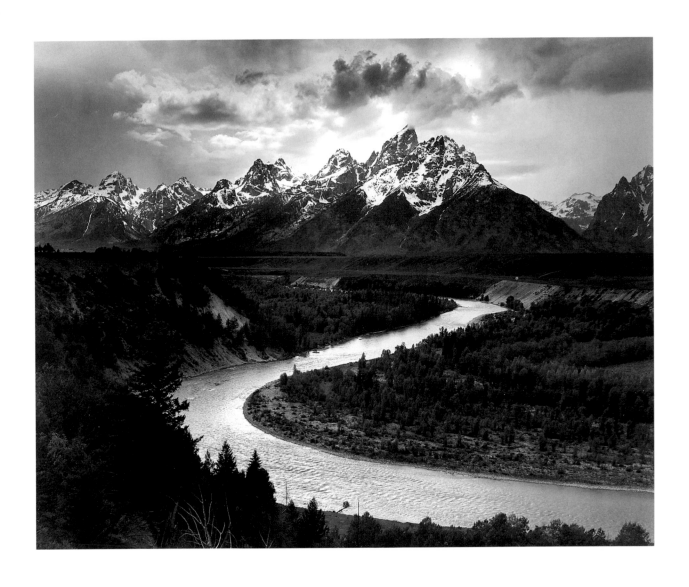

The Tetons and the Snake River, Grand Teton National Park, Wyoming, 1942

Will arrive at Billings, Montana, tonight; then to Yellowstone, then to Glacier, then on west to Rainier and Crater Lake, then home. Have been getting some perfectly swell negatives; developing them in National Park Service darkrooms, and am immensely pleased. Got a superb picture of the Never Summer Range west of Rocky Mountain National Park — great snow-covered mountains with shaded snow-covered hills in the foreground and a very nostalgic sky. Well, wait and see!! I will send some on.

We are roughing it through a deep canyon; can just see the tops of the walls from the Pullman window. Green grassy slopes, yellow-cream rocks, sagebrush. Just passed about fifty miles of snowy mountains — so many mountains here there is no chance to remember what they are.

They take off the Pullman soon; then in a day coach to Billings, Montana: arrive at 6 — take coach at 11 P.M., get off at Livingston at 2:15 A.M. Wait for stage to Gardiner then take government car from Gardiner to Yellowstone. Tell old [William Henry] Jackson I will be thinking of him. He might have had a portable darkroom and a 57 x 1118 camera, but I got 280 pounds of baggage and cameras and tripods and typewriters and am having a hell of a time without the old station wagon!!

From a letter to Nancy Newhall, June 11, 1942

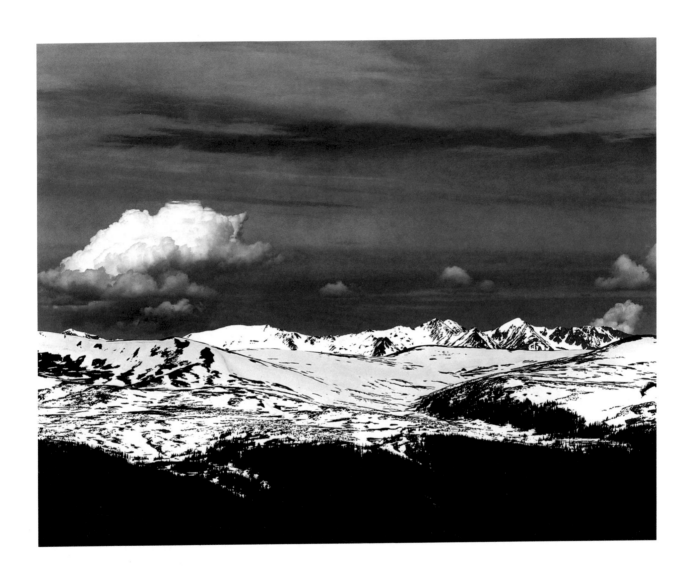

Never Summer Range, Rocky Mountain National Park, Colorado, 1942

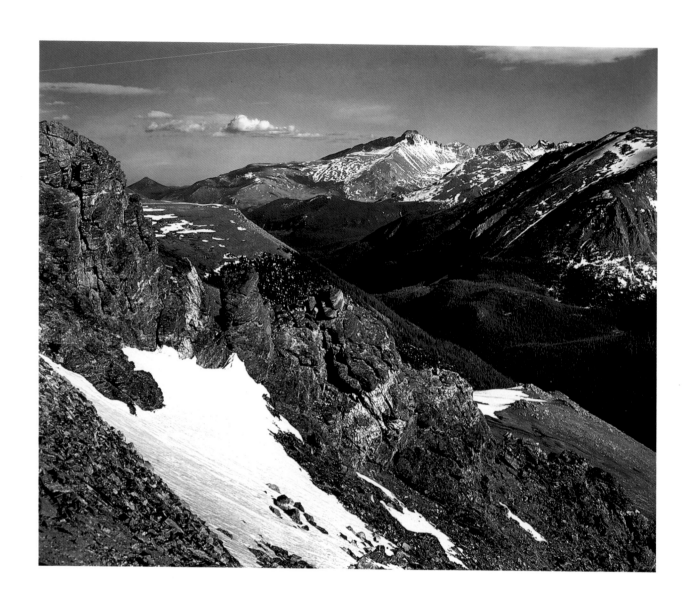

Long's Peak from north, Rocky Mountain National Park, Colorado, 1942

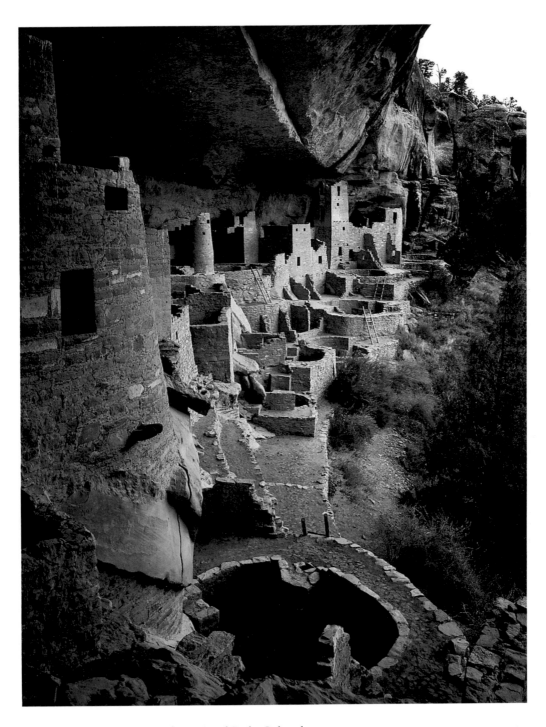

Cliff Palace Ruin, Mesa Verde National Park, Colorado, 1941

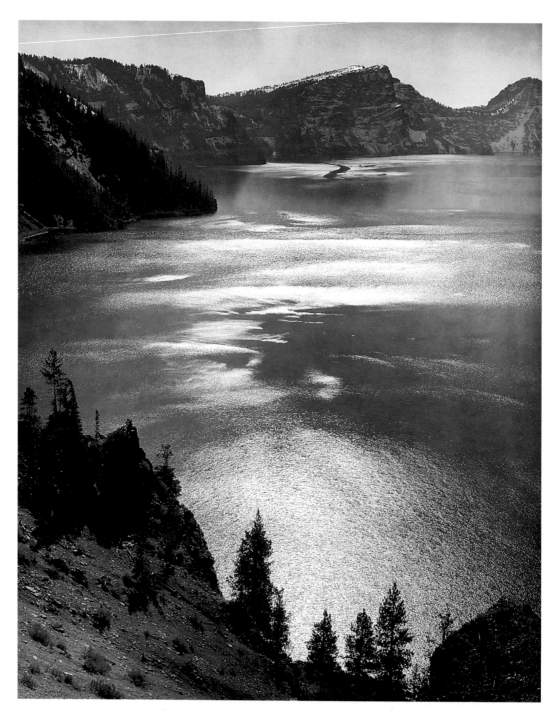

Afternoon Sun, Crater Lake National Park, Oregon, 1943

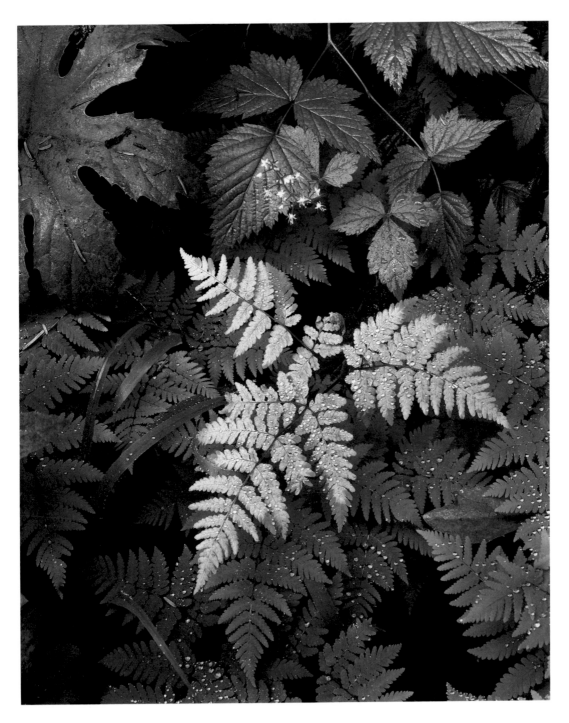

Leaves, Mount Rainier National Park, Washington, c. 1942

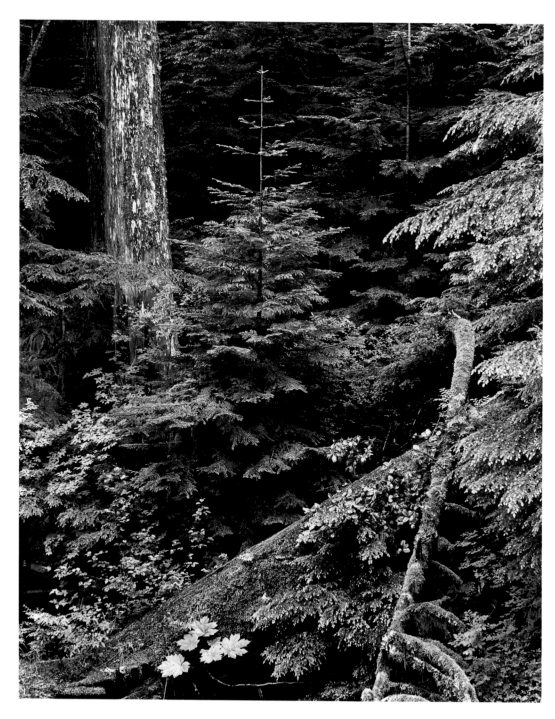

Forest, Early Morning, Mount Rainier National Park, Washington, 1949

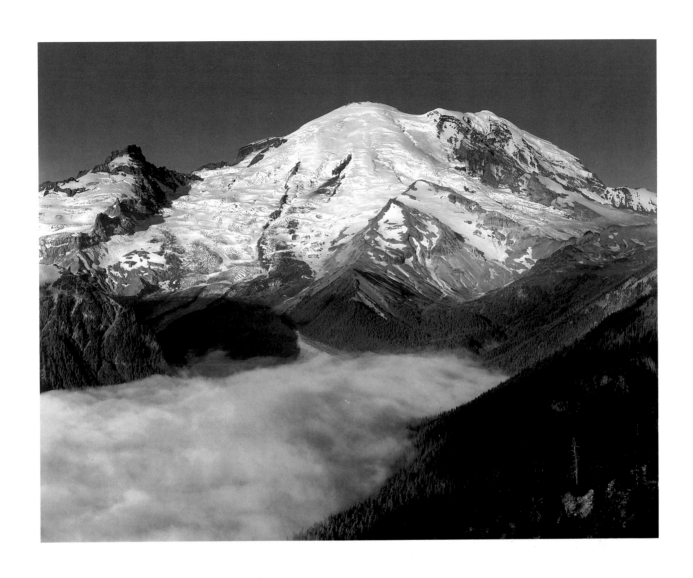

Mount Rainier, Sunrise, Mount Rainier National Park, Washington, 1948

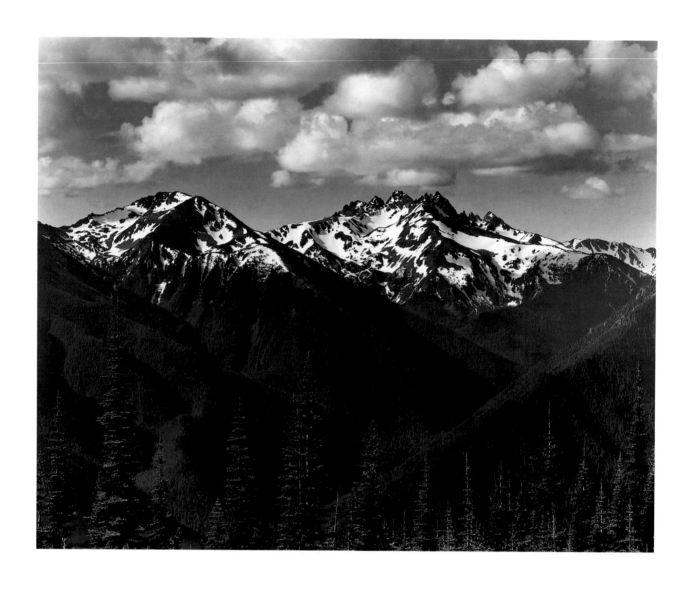

From Hurricane Hill, Olympic National Park, Washington, c. 1950

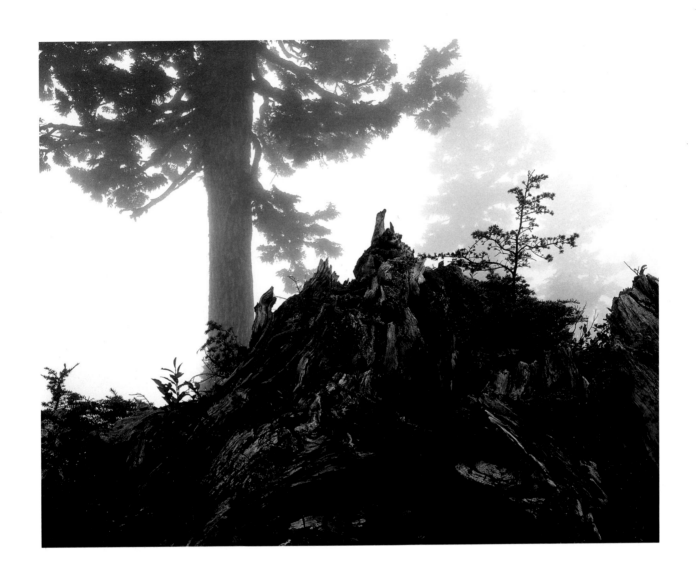

Tree, Stump, Mist, North Cascades National Park, Washington, 1958

Upon receiving the Guggenheim, I decided to travel to Glacier Bay and Mount McKinley (now called Denali) National Parks in Alaska. Since a trip to the state of Washington in 1942, I had sensed that this northwest country was only the threshold of a certain mystery: the dark evergreens, the northern haze, the shining summits of the Olympic Mountains to the west, and the soaring cone of Mount Rainier below the rising sun suggested further grandeurs to the north. Imaginatively inclined, I felt Alaska might be close to the wilderness perfection I continuously sought.

From *Ansel Adams: An Autobiography*, 1985

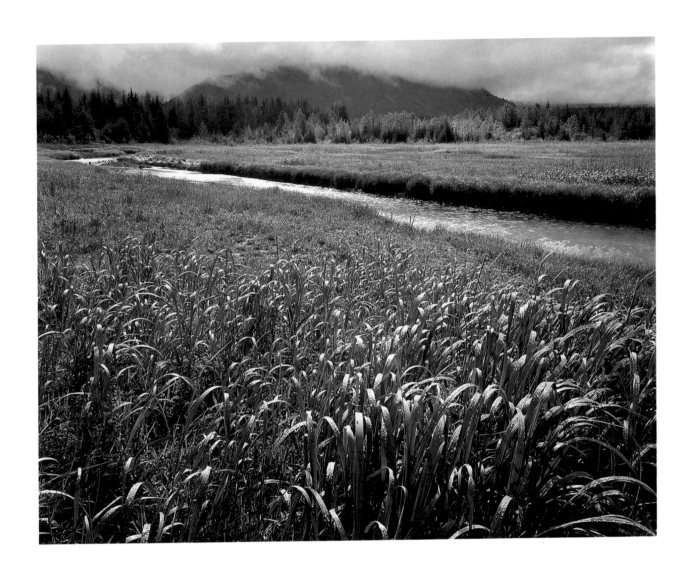

Rain, Beartrack Cove, Glacier Bay National Park, Alaska, 1949

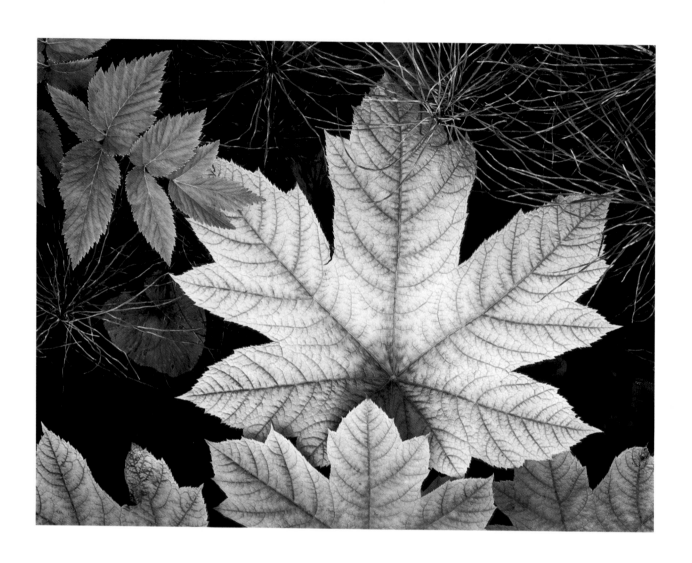

Leaf, Glacier Bay National Park, Alaska, 1948

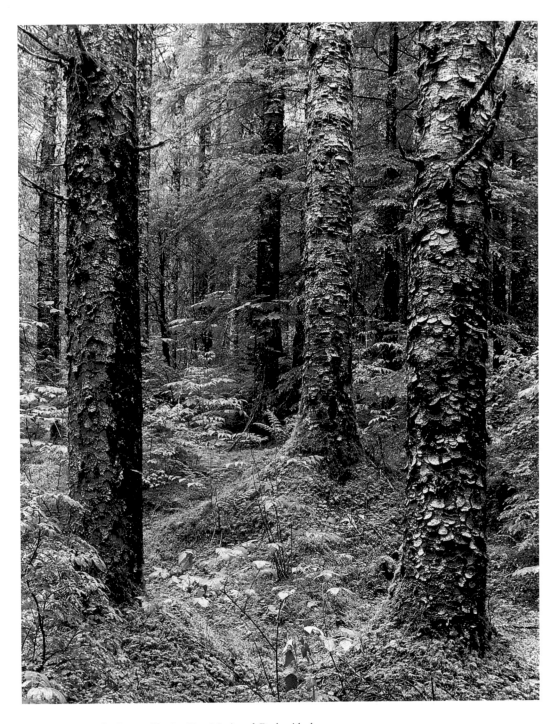

Forest, Beartrack Cove, Glacier Bay National Park, Alaska, 1949

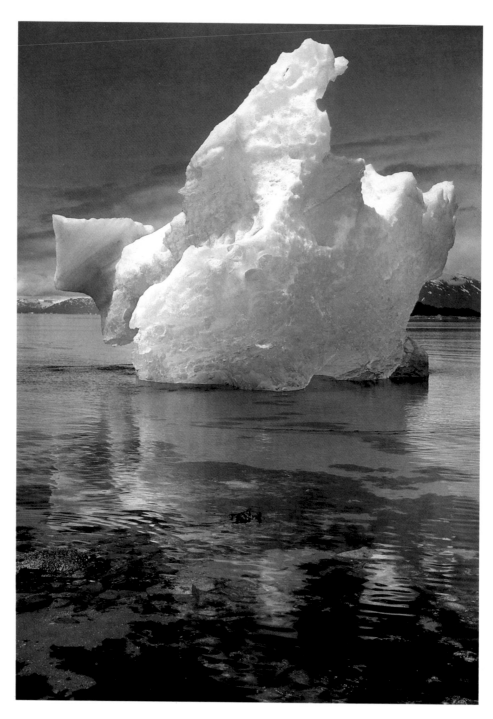

Grounded Iceberg, Glacier Bay National Park, Alaska, 1948

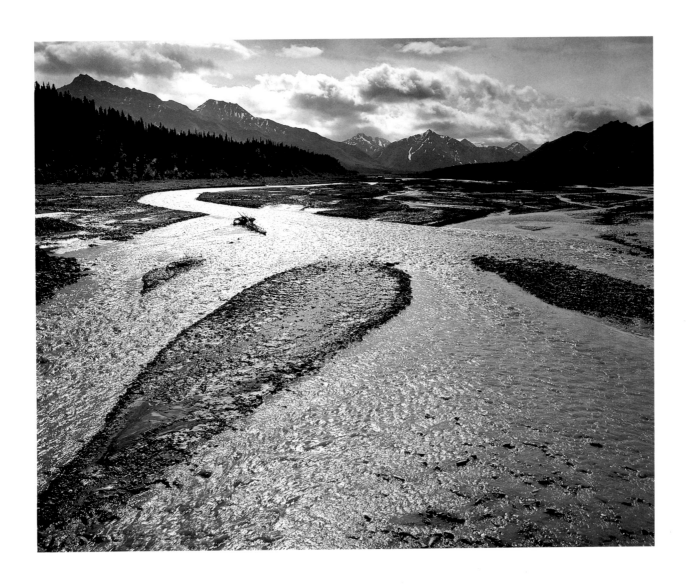

Teklanika River, Denali National Park, Alaska, 1947

As I spent the quiet days in the wild regions of Alaska, I clarified my own concepts of re-creation versus recreation. I saw more clearly the value of true wilderness and the dangers of diluting its finest areas with the imposed accessories of civilization. In Alaska I felt the full force of vast space and wildness. In contrast, the wild areas of our other national parks in the Lower Forty-eight are relatively confined and threatened with increasing accessibility and overstressed facilities. . . .

The quality of place, the reaction to immediate contact with earth and growing things that have a fugal relationship with mountains and sky, is essential to the integrity of our existence on this planet. On this rainy trip to Glacier Bay, I realized the magnitude of the problem and resolved to dedicate as much of my time and energy to it as I could.

From *Ansel Adams: An Autobiography*, 1985

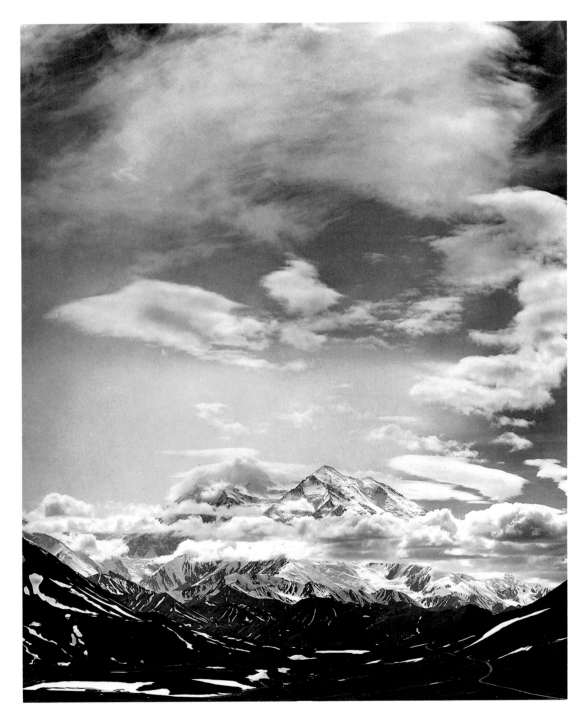

Mount McKinley from Stoney Pass, Denali National Park, Alaska, 1948

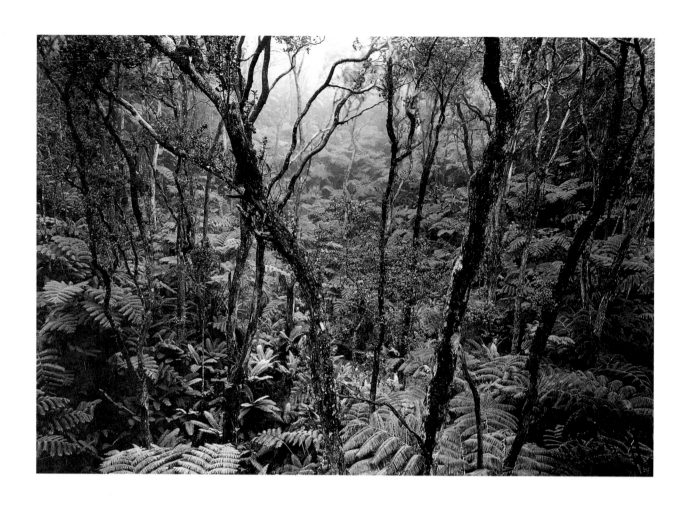

Fern Forest, Kilauea Crater, Hawaii Volcanoes National Park, Hawaii, 1948

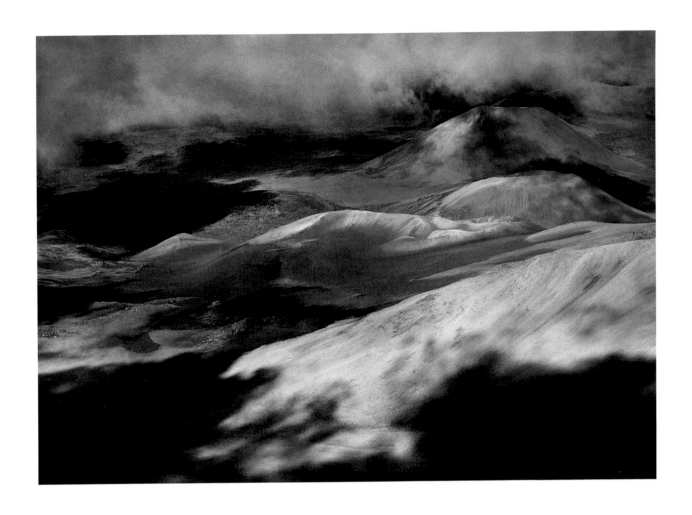

In the Crater of Haleakala, Clouds, Haleakala National Park, Hawaii, 1948

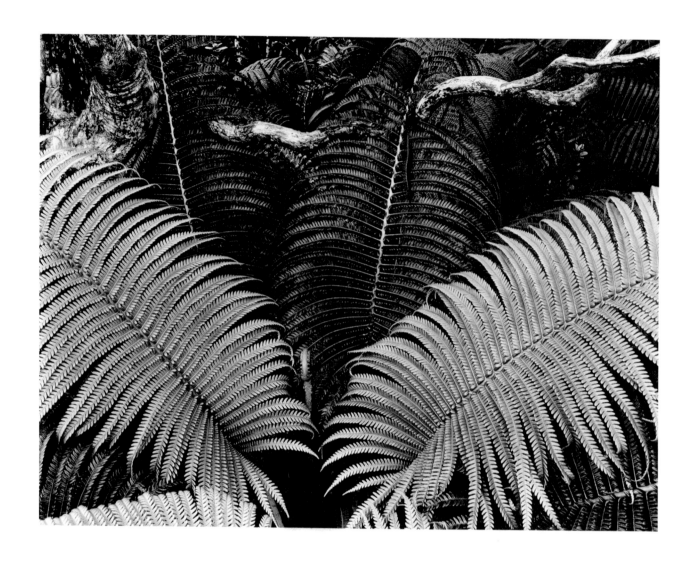

Ferns, near Kilauea Crater, Hawaii Volcanoes National Park, Hawaii, c. 1957

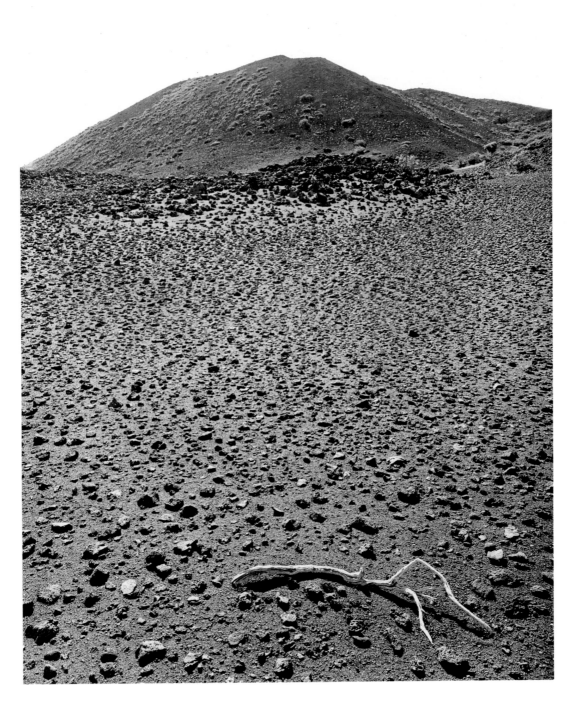

Cinder Cone in the Crater of Haleakala, Haleakala National Park, Hawaii, c. 1956

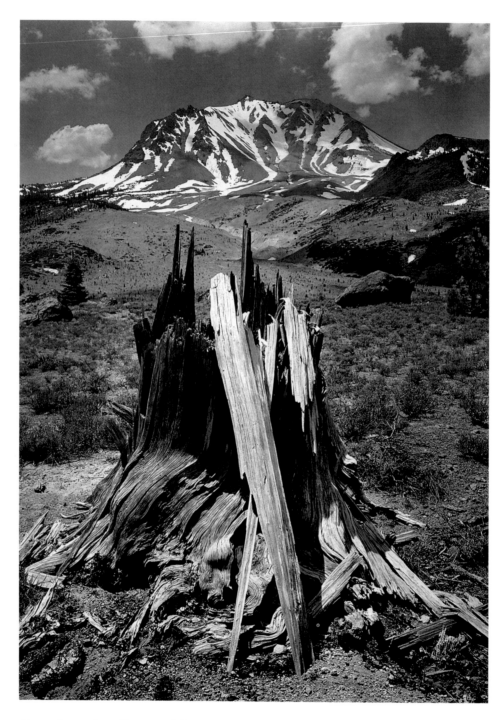

Mount Lassen from Devastated Area, Lassen Volcanic National Park, California, 1949

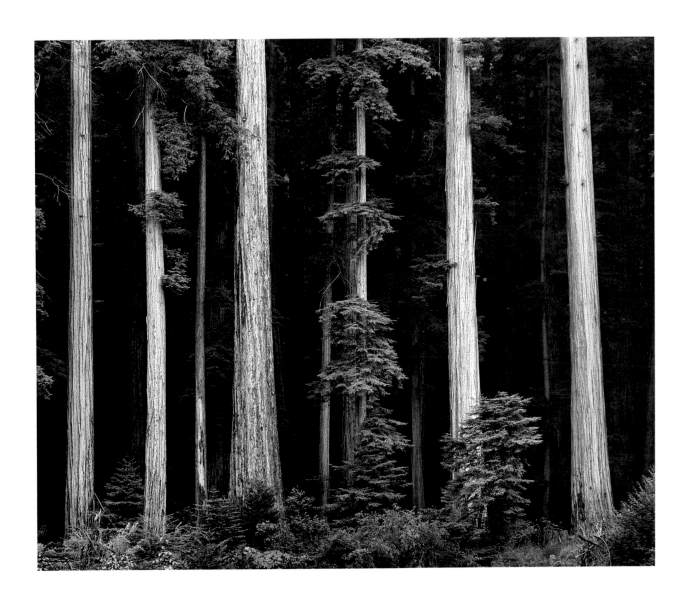

Redwoods, Bull Creek Flat, south of Redwood National Park, California, c. 1960

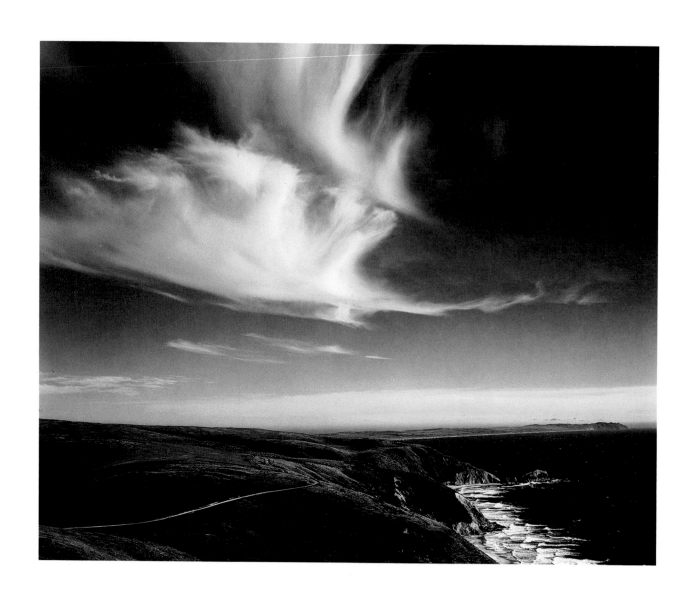

Coast looking south toward Point Reyes National Seashore, California, 1958

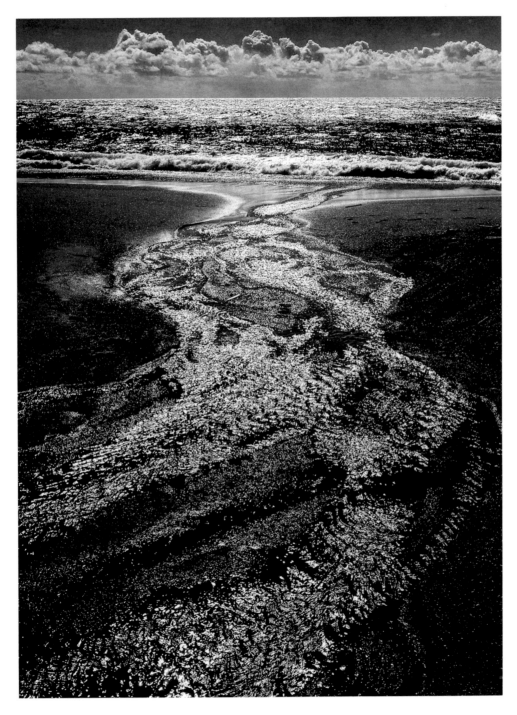

Stream, Sea, Clouds, Rodeo Lagoon, Golden Gate National Recreation Area, California, 1962

There are rumors of pressures being brought to bear on the Military to release the Marin County areas for commercial development. I feel that release of these areas — at least those areas within a mile or two of the north shore of the Golden Gate — would have a serious effect on the world-wide beauty of the Golden Gate. It is difficult to imagine a more impressively scenic region than that comprised by the Marin hills above the Golden Gate from The Golden Gate Bridge to Point Bonita (and northwards to Muir Beach).

This region is not only spectacular, but provides excellent terrain for hiking and scenic enjoyment. A few trails could be provided which would enable people to walk along the cliffs and shoreline. . . .

I contend that if the Army could initiate action to establish State Park status for these areas it would help to forestall further demands for their commercial development and it would also create a favorable-to-the-Army reaction among our citizens who would benefit by this action.

From a letter to General Willard Wyman,
Commandant of the Presidio and the Sixth Army,
March 6, 1954

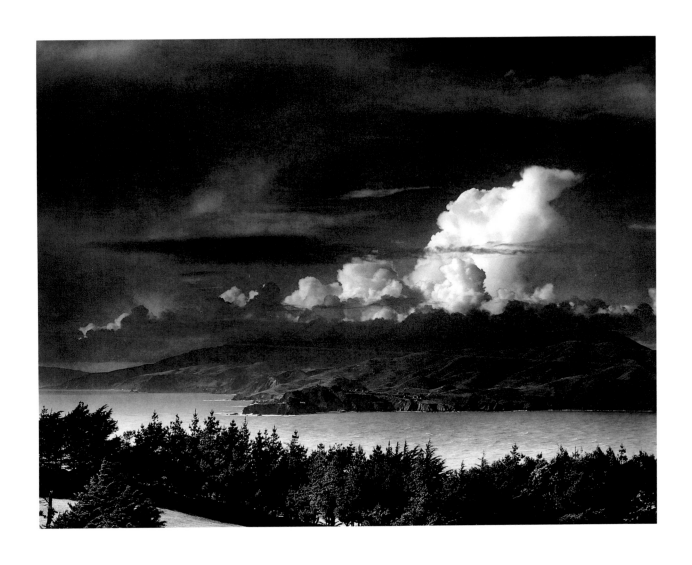

The Golden Gate Headlands from Lincoln Park, Golden Gate National Recreation Area, California, c. 1950

Plans for a family visit to Yosemite in the spring of 1916 stirred a new and great expectancy. A month before the great event I was given [J. M.] Hutchings' *In the Heart of the Sierras*, and pored over it, building fantasies of Indians and bears, of huge waterfalls and precipices, of stagecoaches creaking on the edge of catastrophe, of remoteness and magic. The known qualities of the sea merged with the unknown qualities of rivers and waterfalls, the redwoods of Santa Cruz with the Sequoia-gods of Wawona. The days became prisons of impatience and restlessness. Finally, the train at Oakland! All day long we rode, over the Coast Range, through Niles and Livermore, down across the heat-shimmering San Joaquin Valley, up through the even hotter foothills to the threshold of Yosemite. I can still feel the furnace blasts of air buffeting through the coaches, and hear the pounding, roaring exhaust of the locomotive re-echoing from the steep walls of the Merced Canyon. Then arrival at El Portal, and a night spent in an oven of a hotel, with the roar of the river beating through the sleepless hours until dawn. And finally, in the bright morning, the grand, dusty, jolting ride in an open motor bus up the deepening, greening gorge to Yosemite.

That first impression of the valley — white water, azaleas, cool fir caverns, tall pines and stolid oaks, cliffs rising to undreamed-of heights, the poignant sounds and smells of the Sierra, the whirling flourish of the stage stop at Camp Curry with its bewildering activities of porters, tourists, desk clerks, and mountain jays, and the dark green-bright mood of our tent — was a culmination of experience so intense as to be almost painful. From that day in 1916 my life has been colored and modulated by the great earth-gesture of the Sierra.

From the Introduction to *Yosemite and the Sierra Nevada*, 1948

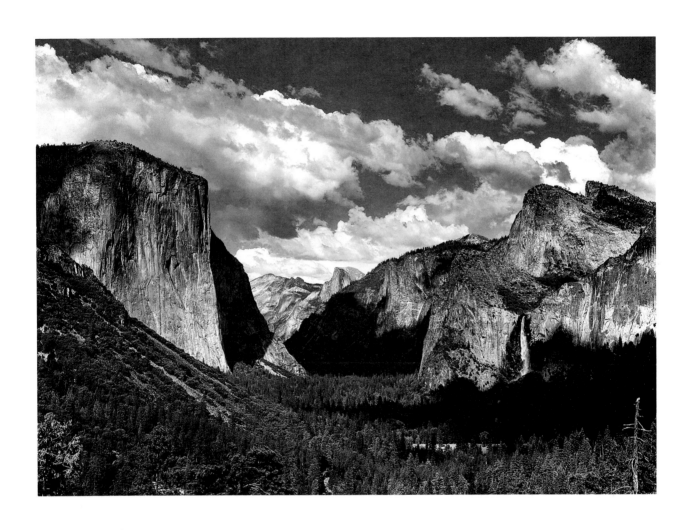

Yosemite Valley, Summer, Yosemite National Park, California, c. 1935

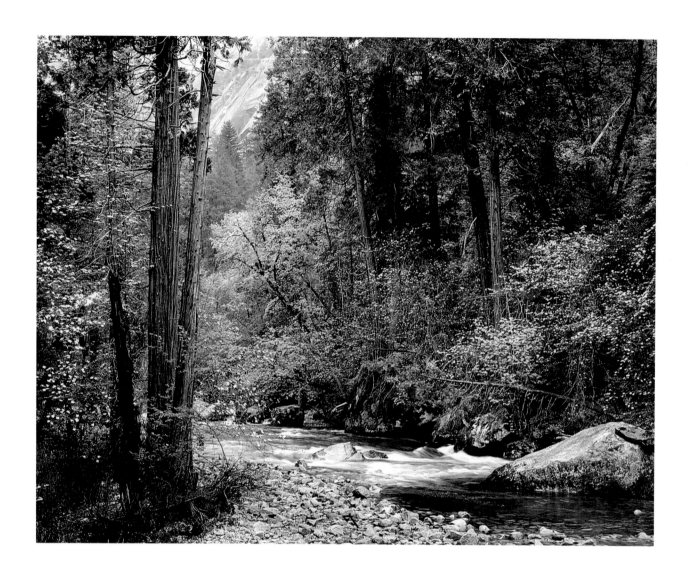

Tenaya Creek, Dogwood, Rain, Yosemite National Park, California, c. 1948

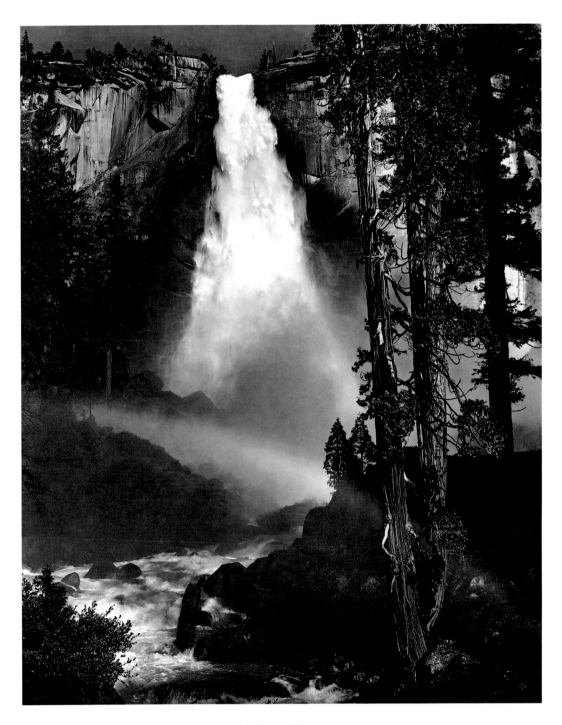

Nevada Fall, Rainbow, Yosemite National Park, California, c. 1947

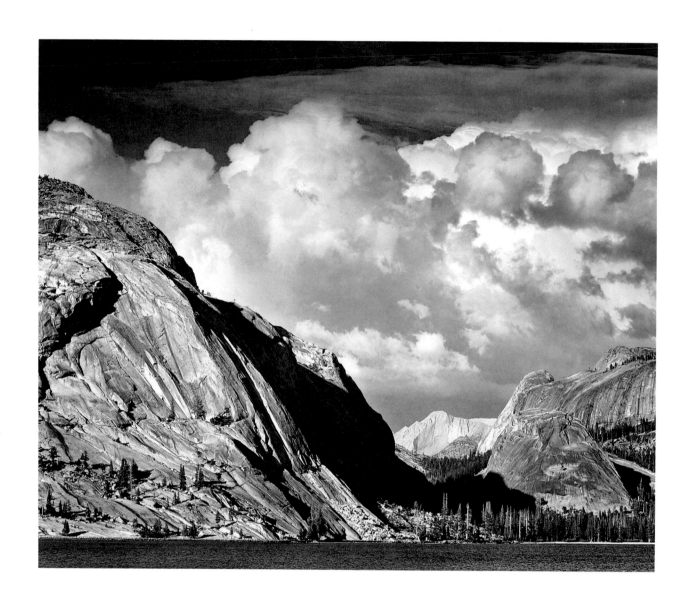

Tenaya Lake, Mount Conness, Yosemite National Park, California, c. 1946

WESTERN UNION

1220

W. P. MARSHALL, PRESIDENT

SAN FRANCISCO CALIF

The filing time shown in the date line on telegrams and day letters is STANDARD TIME at point of origin. Time of receipt is STANDARD TIME at point of destination

ZD 227 NL PD BD OTR "CFN" (BOOK 3 WITH INSERTS) JULY 7-58 SK 17 T282

1-HON FRED SEATON SECTY OF THE INTERIOR WASHDC COPY OF THIS WIRE SENT TO
 SECRETARY WEEKS AND DIRECTOR WIRTH

2-HON SINCLAIR WEEKS SECTY OF COMMERCE WASHDC COPY OF THIS WIRE SENT TO
 FRED SEATON AND DIRECTOR WIRTH

3-MR CONRAD WIRTH DIRECTOR NATIONAL PARK SERVICE WASHDC COPY OF THIS WIRE
 SENT TO SECRETARY WEEKS AND FRED SEATON.

AS AN INDIVIDUAL AND NOT AS A DIRECTOR OF THE SIERRA CLUB OR AS A
TRUSTEE OF TRUSTEES FOR CONSERVATION I WISH TO LODGE A MOST
SINCERE AND SEVERE PROTEST AGAINST THE DESECRATION OF TENAYA LAKE
AND THE ADJOINING CANYON IN YOSEMITE/PARK WHICH IS BEING PERPETRATED
BY THE RUTHLESS CONSTRUCTION OF THE NEW TIOGA ROAD FOR THE NATIONAL
PARK SERVICE BY THE BUREAU OF PUBLIC ROADS. THE CATISTROPHIC DAMAGE IS
ENTIRELY UNNECESSARY AND VIOLATES THE PRINCIPALS EXPRESSED IN THE
NATIONAL PARK ORGANIC ACT OF 1916 WHICH IS ACCEPTED BY OUR PEOPLE
AS THE BASIS OF PROTECTION OF OUR MAGNIFICENT NATURAL SCENE FOR OUR
TIME AND FOR THE TIME TO COME. I CONSIDER THIS DESECRATION AN ACT OF
DISREGARD OF THESE BASIC CONSERVATION PRINCIPALS WHICH APPROACHES CRIMINAL
NEGLIGENCE ON THE PART OF THE BUREAUS CONCERNED. I URGENTLY REQUEST YOU
ISSUE AN ORDER OF IMMEDIATE CESSATION OF WORK ON THE TIOGA ROAD IN THE
TANEYA LAKE AREA UNTIL A TRULY COMPETENT GROUP CAN STUDY THE PROBLEMS AND
SUGGEST WAYS AND MEANS OF ACCOMPLISHING COMPLETION OF THIS PROJECT WITH
MINIMUM DAMAGE. I HAVE NEVER OPPOSED APPROPRIATE IMPROVEMENT OF THE TIOGA
ROAD BUT IN 40 YEARS EXPERIENCE IN NATIONAL PARK AND WILDERNESS AREAS I HAVE
NEVER WITNESSED SUCH AN INSENSITIVE DISREGARD OF PRIME NATIONAL PARK VALUES
RESPECTFULLY
 ANSEL ADAMS
MAIL
 MR ANSEL ADAMS
 131 24TH AVE SFRAN

Telegram to Secretary of Interior, Secretary of Commerce, and Director, National Park Service, July 7, 1958

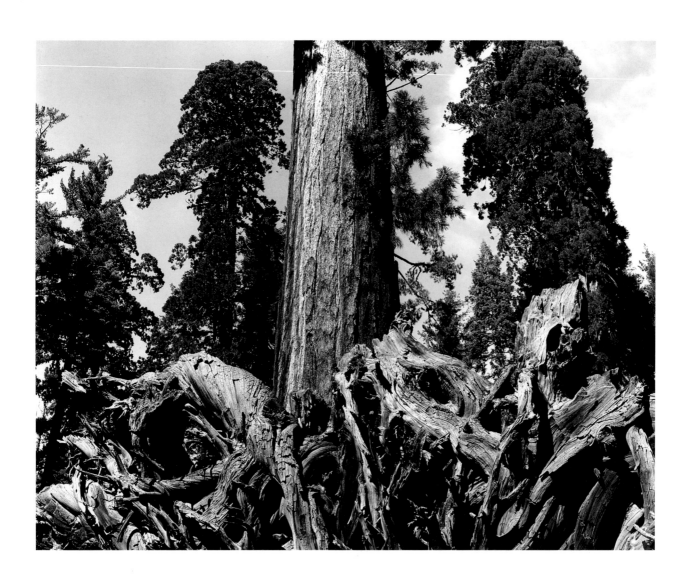

Redwood Roots and Tree, Mariposa Grove, Yosemite National Park, California, 1944

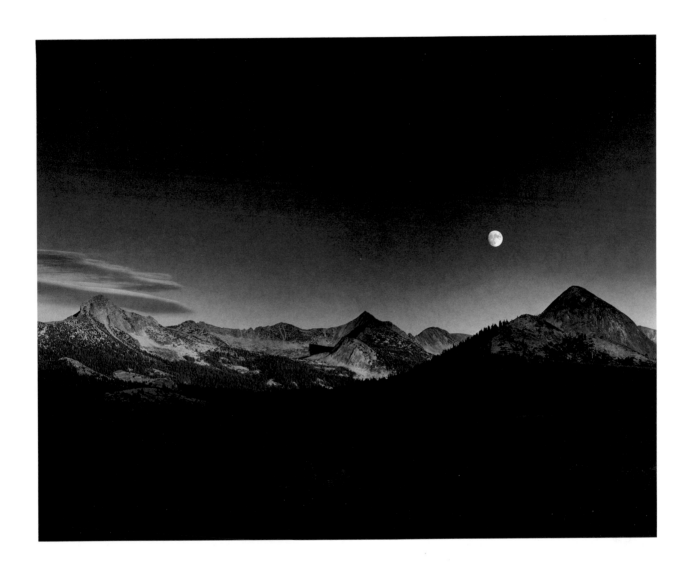

Autumn Moon, the High Sierra from Glacier Point, Yosemite National Park, California, 1948

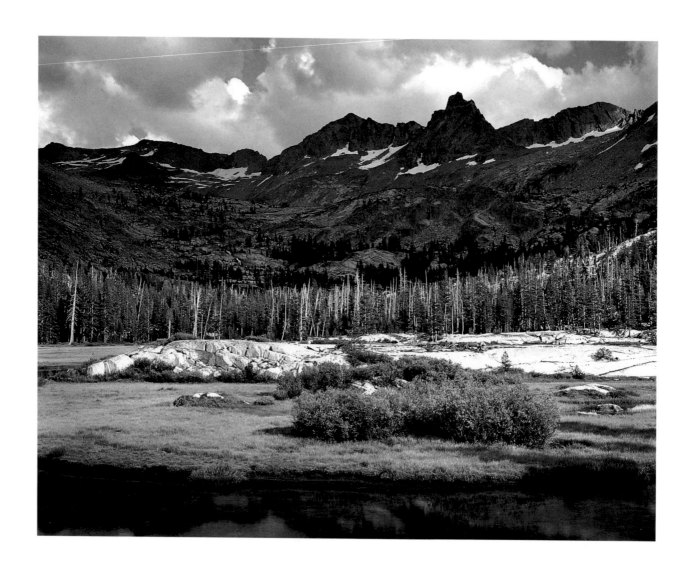

Mount Ansel Adams, Lyell Fork of the Merced River, Yosemite National Park, California, c. 1935

In midafternoon we reached the Lyell Fork of the Merced River and turned left for a mile of cross-country wilderness travel through lodgepole and hemlock pines to the meadows where we were to set up camp. We were ringed to the east and south with rugged peaks: the less severe slopes were to the north and, beyond the forest to the west, a valley opened yielding an expansive view of the encircling Merced Range.

Dave [McAlpin] asked me to name the peaks we were seeing to the east; Rodgers Peak was hidden by a ridge, the summit of Elektra Peak and the north flank of Forester Peak could be seen. A rock tower, actually the end of a metamorphic ridge, rose before the background summits. I casually remarked that the Sierra Club had named this little peak after me during a trip in 1934 when I introduced the annual High Sierra outing party to this area. I hastened to add that a natural feature cannot be named for a living person; their kind gesture was really a friendly nomination. [Georgia] O'Keeffe needled me for days on this admission. "Oh, *now* I see why you brought us here, just to show off your mountain!" I vigorously denied such intentions. She admitted that it *was* a nice little mountain and, "You should be proud of it."

From *Ansel Adams: An Autobiography*, 1985

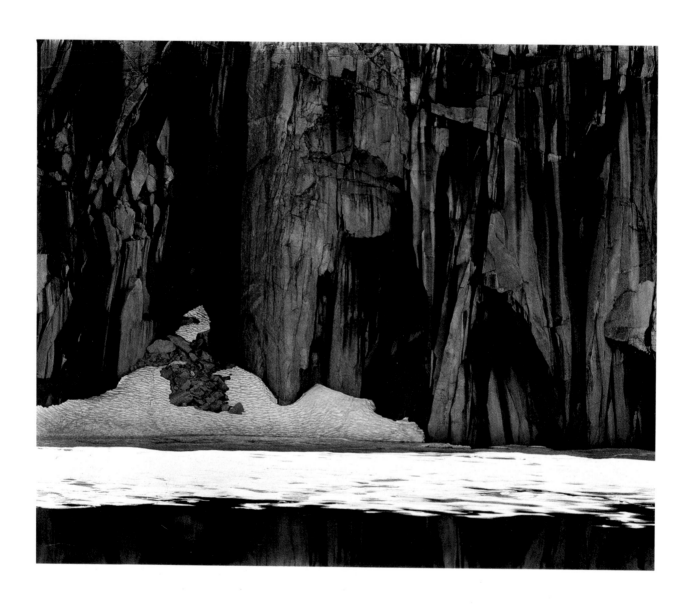

Frozen Lake and Cliffs, Sequoia National Park, California, 1932

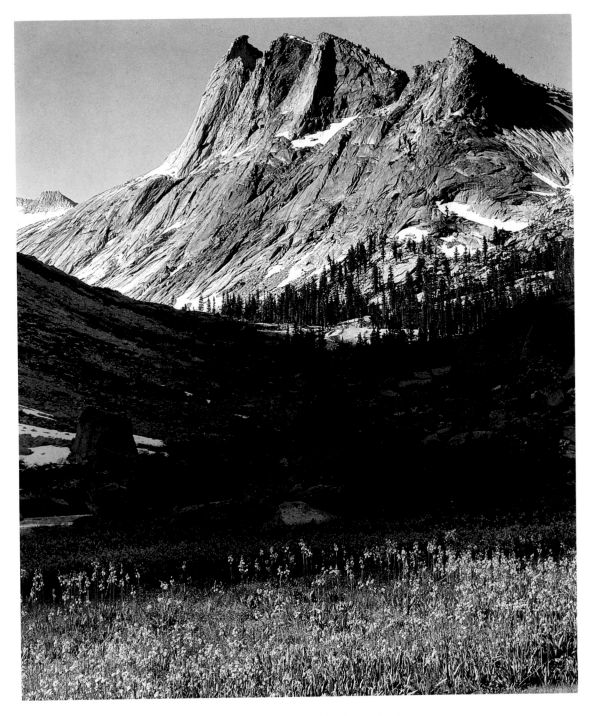

Big Bird Peak, Deadman Canyon, Kings Canyon National Park, California, c. 1934

An important conference was called in 1936 in Washington, D.C., to discuss the future of both our national and state parks. The Sierra Club board of directors asked me to travel to Washington and lobby for the establishment of Kings Canyon National Park. They suggested that my photographs of this region would prove to our legislators the unique beauty of the area. Using photographs as a lobbying tool had proven helpful in the past. Carleton Watkins's photographs of Yosemite had great positive effect on the efforts that made Yosemite Valley a state park in 1864, and William Henry Jackson's photographs of Yellowstone had been a deciding factor in the establishment of our first national park in 1872.

With total naïveté, I ventured into the strange wilderness of our nation's capital with a portfolio of photographs under my arm, visiting congressmen and senators in their lairs. I boldly proclaimed the glories of the High Sierra and showed my pictures with the unabashed confidence that they would prove our contention. I was asked to address the conference and thereby became acquainted with Secretary of the Interior Harold Ickes. My unsophisticated presentation of photographs, coupled with appropriately righteous rhetoric, stirred considerable attention in Congress for our cause — although I returned home with no firm commitments on behalf of Kings Canyon National Park.

From *Ansel Adams: An Autobiography*, 1985

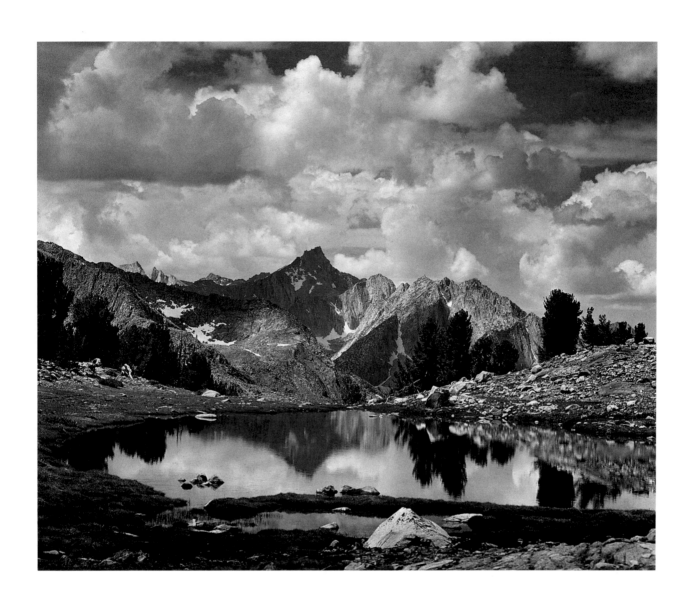

Mount Clarence King, Pool, Kings Canyon National Park, California, c. 1925

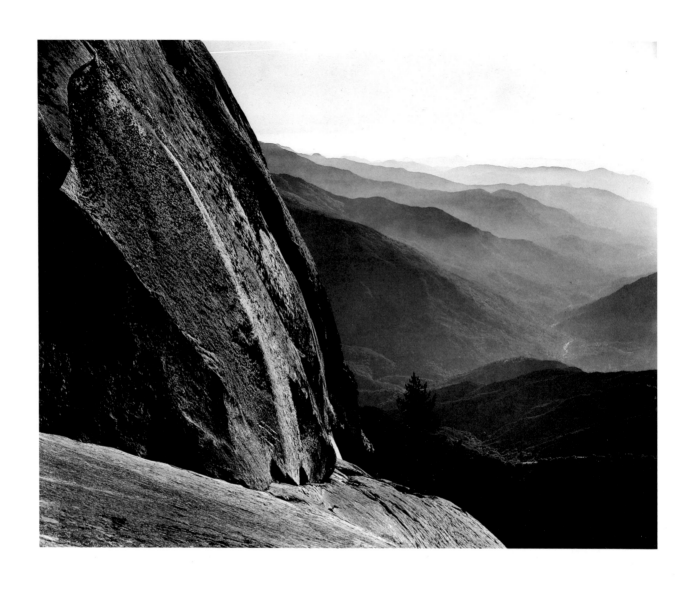

Moro Rock, Sequoia National Park, and Sierra Foothills, California, 1945

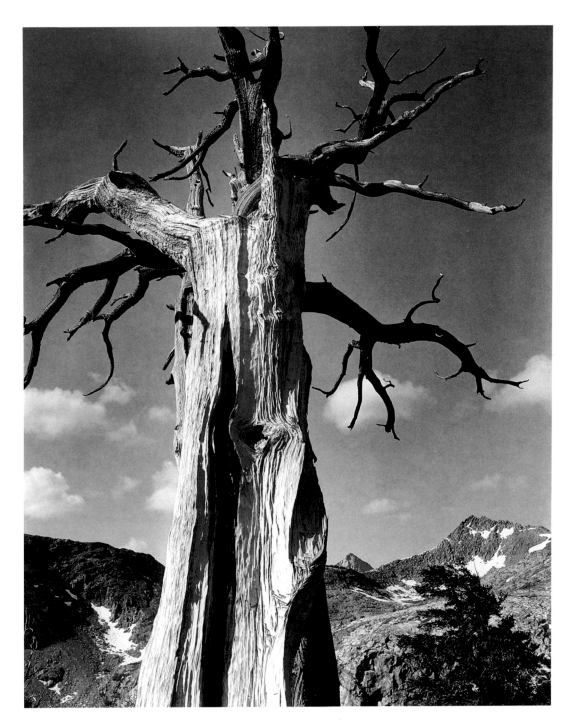

Dead Tree near Little Five Lakes, Sequoia National Park, California, c. 1932

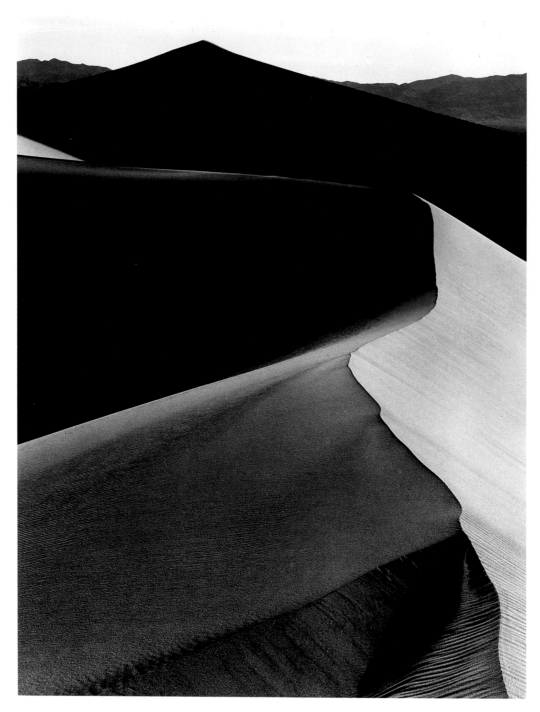

Sand Dunes, Sunrise, Death Valley National Monument, California, c. 1948

I was camped in my car near Stovepipe Wells, usually sleeping on top of my car on the camera platform, which measured about 5 x 9 feet. Arising long before dawn, I made some coffee and reheated some beans, then gathered my equipment and started on the rather arduous walk through the dunes to capture the legendary dune sunrise. Several times previously I had struggled through the steep sands with a heavy pack only to find I was too late for the light or I encountered lens-damaging wind-blown sand. The dunes are constantly changing, and there is no selected place to return to after weeks or months have passed.

A searing sun rose over the Funeral Range, and I knew it was to be a hot day. Fortunately I had just arrived at a location where an exciting composition was unfolding. The red-golden light struck the dunes, and their crests became slightly diffuse with sand gently blowing in the early wind. To take full advantage of the sunrise colors on the dunes I worked first with 4 x 5 Kodachrome. . . . Then, without moving the camera, I made several exposures with black-and-white film. . . .

Within fifteen minutes the light flattened out on the dunes and I moved back to my car through 90° F and more of Death Valley heat. . . .

From *Examples: The Making of 40 Photographs*, 1983

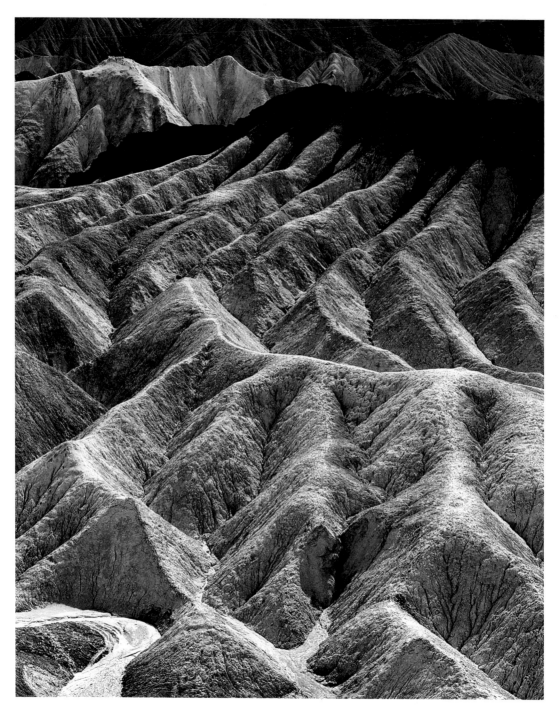

Zabriskie Point, Death Valley National Monument, California, 1942

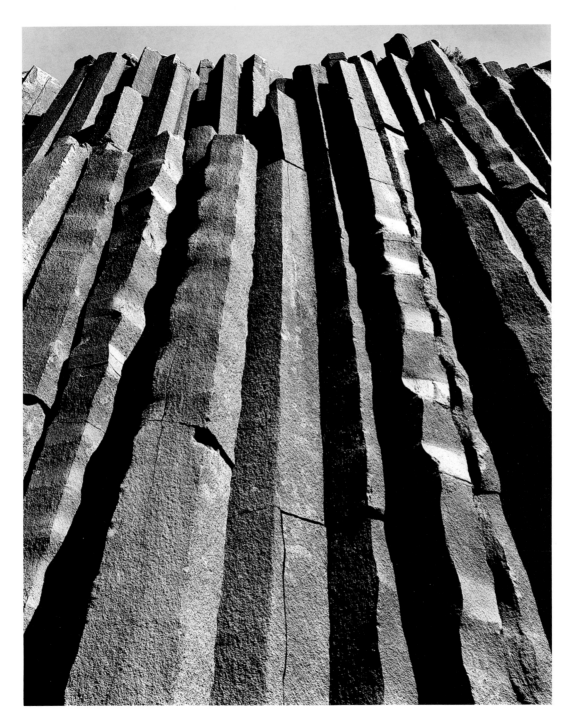

Detail, Devils Postpile National Monument, California, 1946

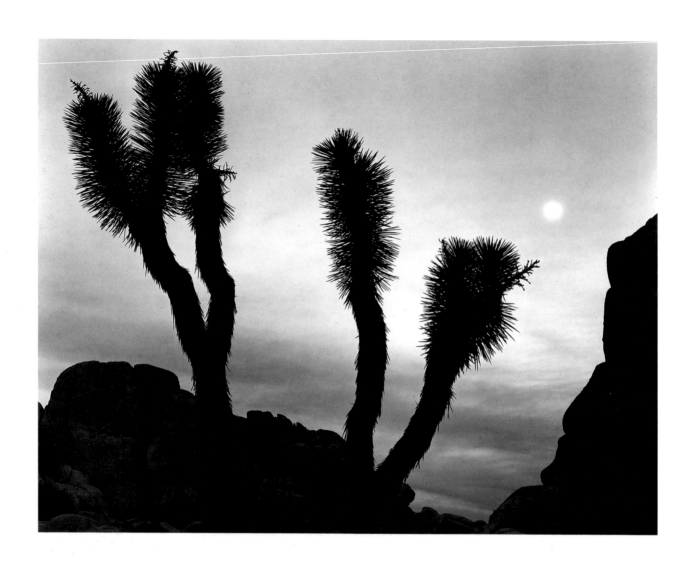

Moonrise, Joshua Tree National Monument, California, 1948

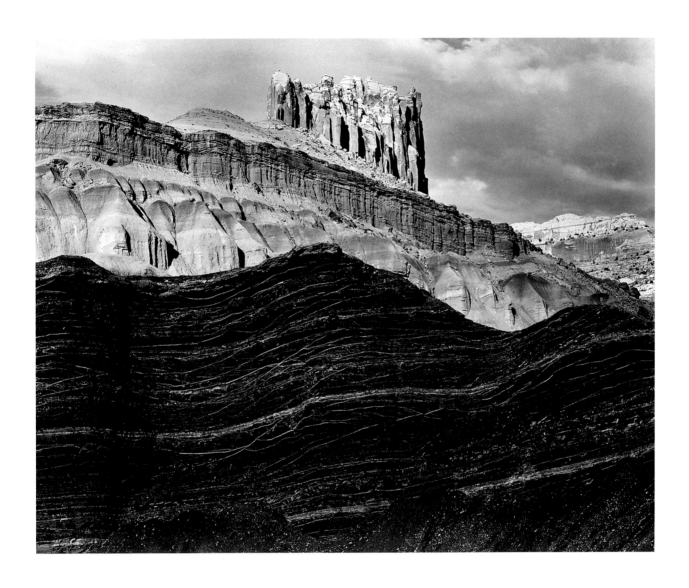

The Castle, Capitol Reef National Park, Utah, 1947

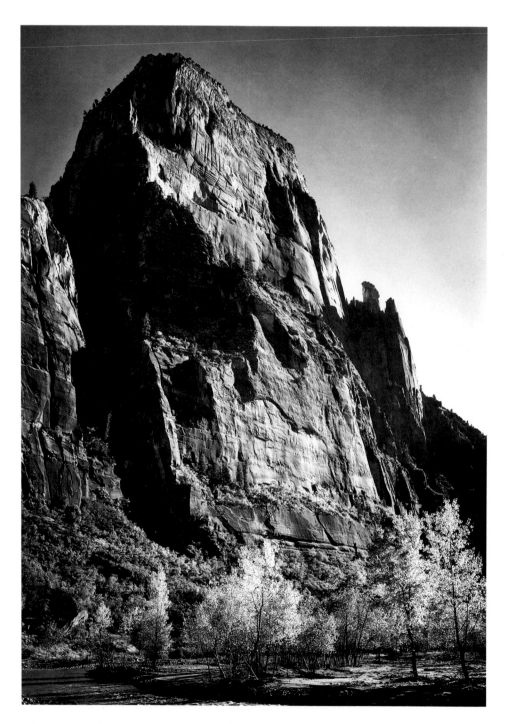

The Great White Throne, Zion National Park, Utah, 1942

The American Pioneer approached the Natural Scene in a very different way than we must now. The land and its provisions were seemingly inexhaustible. The problems of existence were most severe. The Pioneer undoubtedly cherished his farm, his ranch and his range — representing something almost infinite in extent and bounty — young, vibrant, ever-enduring. Now, as the blights of over-population, over-exploitation and over-mechanization encroach from all directions, we come to love our land as we would love someone very near and dear who may soon depart, leaving naught but the recollection of a beauty which we might have protected and perpetuated. We must realize — and with desperate conviction — that it *is* truly later than we think.

From the Charter Day Address,
University of California at Santa Cruz, 1965

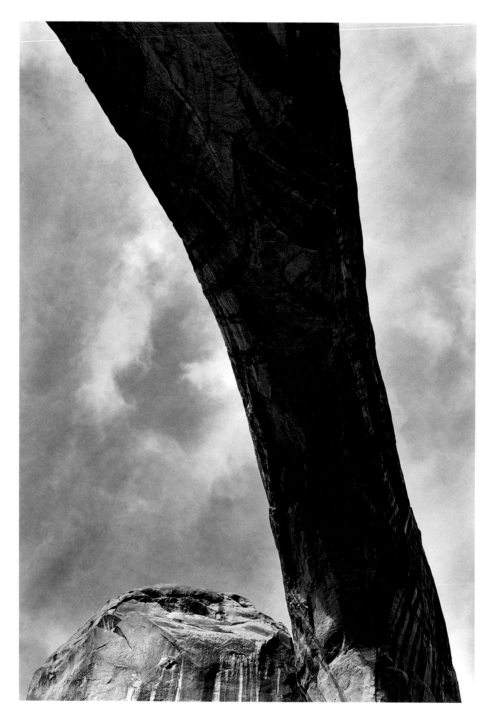

Base of West Arch, Rainbow Bridge National Monument, Utah, c. 1942

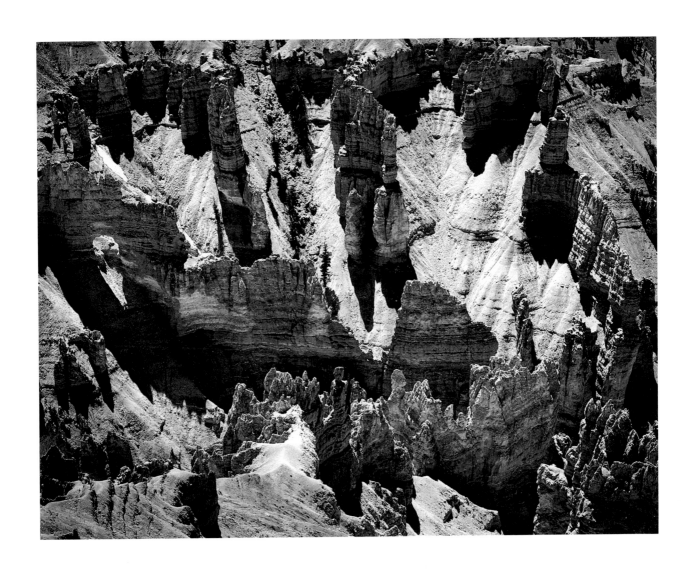

In Cedar Breaks National Monument, Utah, 1947

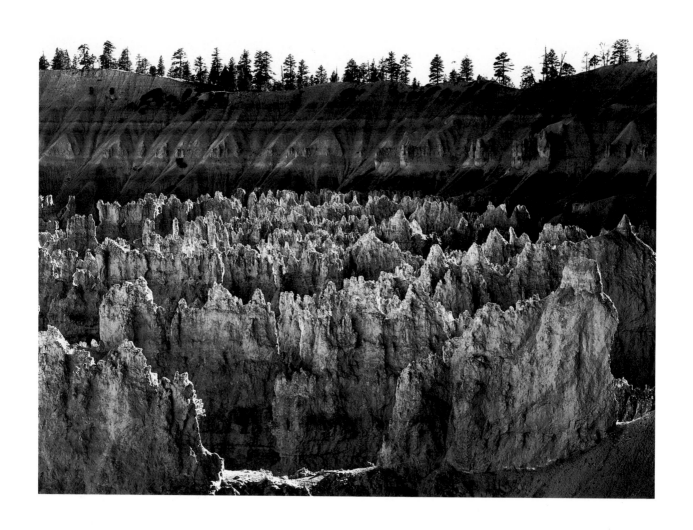

Formations, Bryce Canyon National Park, Utah, 1947

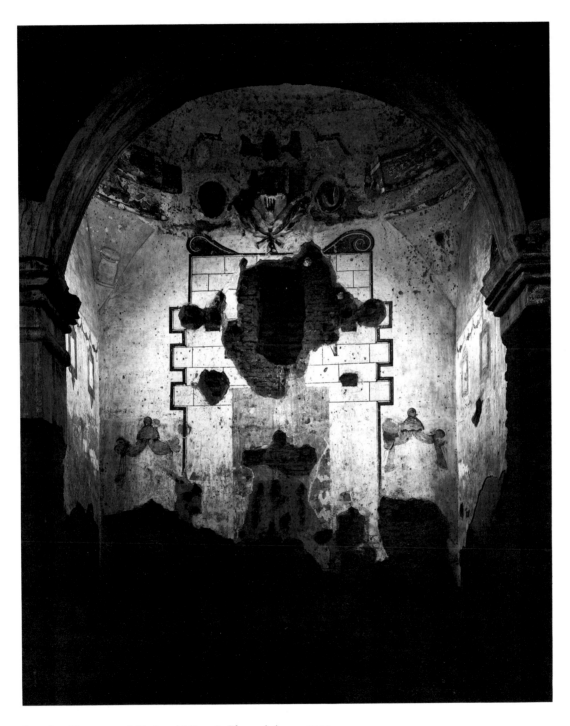

Interior, Tumacacori National Historic Place, Arizona, 1952

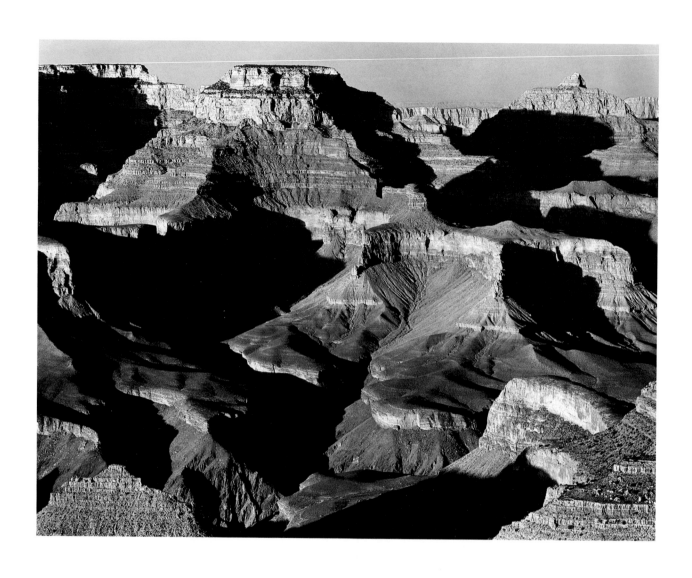

Cape Royal from the South Rim, Grand Canyon National Park, Arizona, 1947

Ye Fred Harvey
SOUTHWESTERN HOTELS

In New Mexico
LA FONDA, SANTA FE
THE ALVARADO, ALBUQUERQUE
EL NAVAJO, GALLUP

In Arizona
LA POSADA, WINSLOW

In Grand Canyon National Park
EL TOVAR HOTEL
BRIGHT ANGEL LODGE

BRIGHT ANGEL LODGE AND CABINS ··· GRAND CANYON NATIONAL PARK, ARIZONA

DEAR B & N June 22
 1951

 I AM BATTLE SCARR'D AND WEARY

 AND MY MIND AND EYES ARE BLEARY

 AND THE DUST OF MANY AEONS GRAYS MY BEARD,

 WELL
 THE HEAT HAS/DE-SALTED ME,

 THE TOURISTS HAVE REVOLTED ME,
 MULES
 BUT THE MULES ARE NOT AS BAD AS I HAD FEAR'D;

 TRAILS
 THE ᴛᴱᴿᴿᴵᴸᵁ DESCEND TO HADES

 AND ENGULF BOTH MULES AND LADIES

 WHO EMERGE WITH ALL EXTREMIRIES FULL SEAR'dD

 BUT IN THE COLORAMA

 NAUGHT BUT RADIENT NIRVANA

 WILL EVER BE, AS EVER HAS APPEAR'D.

 YOUR LETTERS ARE WELCOME. MY REPLIES ARE IMPOSSIBLE. SUNDAY NIGHT AT NORTH

 RIM, WEDNESDAY AT ZION. IN YOSEMITE ABOUT JULY 2nd

 THEN SHALL I WRITE.

 LOVE

 G. AND S. SEND THEIR BEST

 OPEN ALL YEAR

Letter to Beaumont and Nancy Newhall, June 22, 1951

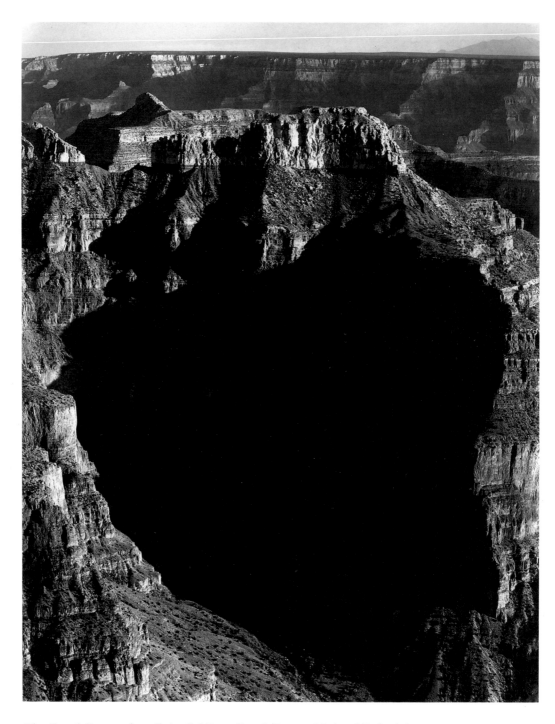

The Grand Canyon from Point Sublime, Grand Canyon National Park, Arizona, 1942

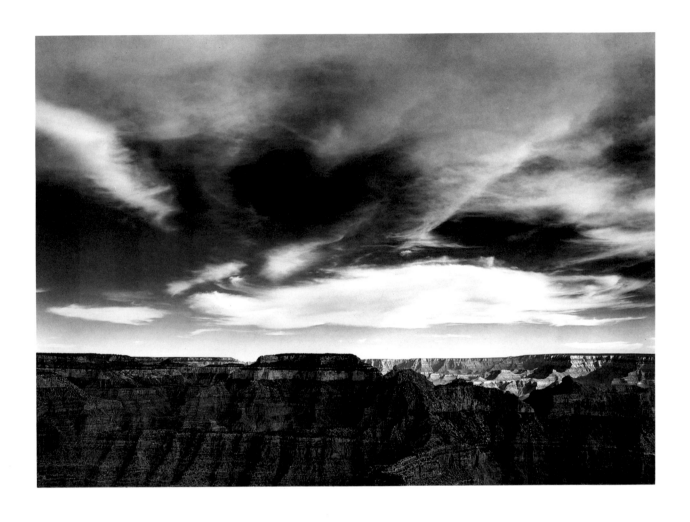

Cliffs and Clouds, Grand Canyon National Park, Arizona, 1942

Friends say to me, "I don't see how the lower Colorado dam can do any harm — only a handful of people see that part of the Canyon anyway." And "with a lake in there people can *easily* (!) see things they would never see before." I suggest we fill the Sistine Chapel about ⅔ full of water so that visitors can float around and see the ceiling paintings to better advantage!

From a letter to a Sierra Club colleague, July 2, 1966

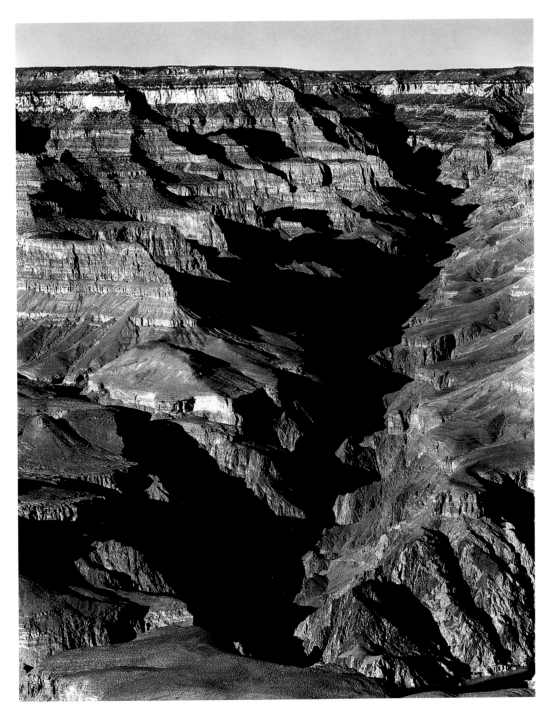

The Grand Canyon from Yavapai Point, Grand Canyon National Park, Arizona, 1942

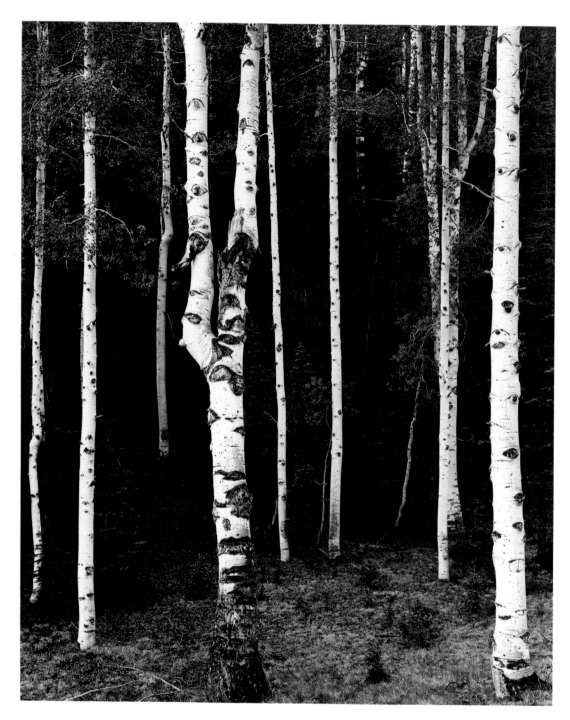

Aspen Grove, North Rim, Grand Canyon National Park, Arizona, 1947

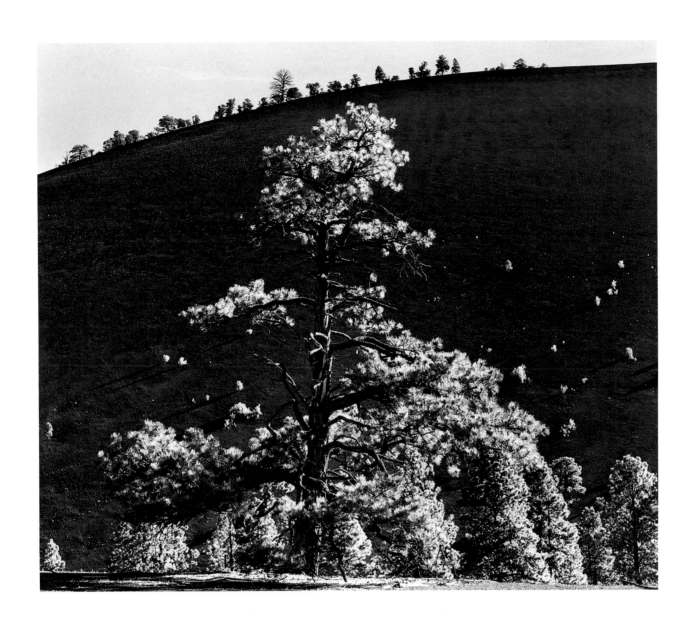

Pumice Slope and Pine Trees, Sunset Crater National Monument, Arizona, 1947

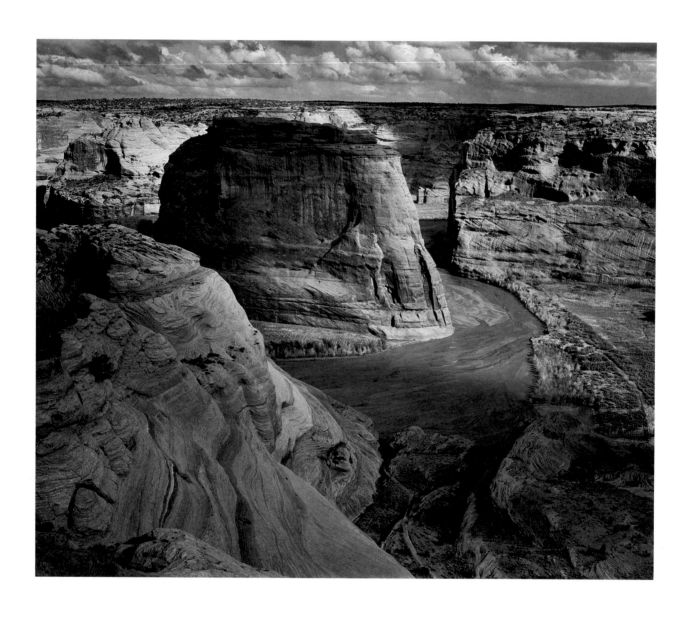

Canyon de Chelly National Monument, Arizona, 1942

We have had a spectacular and dangerous trip. All went well through Death Valley, Boulder Dam, Zion, North Rim, South Rim. Then we spent the night on Walpi Mesa, proceeded to Chinle and had two spectacular, stormy days at Canyon de Chelly. I photographed the White House Ruins from almost the identical spot and time of the O'Sullivan picture! Can't wait until I see what I got. Then our troubles began. They have had the worst rainy season in 25 years and the roads through the Indian Country are unbelievable! The Road from Chinle to Kayenta was so terrible that it took us fifteen hours to go sixty miles; then we ended up at midnight flat on our chassis in the worst mud hole you ever saw — with lightning and thunder and rain roaring on us. We slept in the car that night and worked from 5 A.M. till noon getting the old bus rolling again.

[In Utah we] encountered the Butler Wash. It was running 15 inches deep, so we thought it was safe. I set the car in low and proceeded to barge through as I have many such affairs. When the front wheels touched the far bank the motor stopped — water was thrown on the block by the fan belt. I should have removed it first. Well, there we were with the backside of the car actually under water. In a moment of panic I decided to reverse and get out of it all; I could not budge the car ahead after getting it started because the rear wheels had found a hole and no advance was possible. I put it in reverse, gunned it, got half-way across, and the entire ignition passed out. Here I was, with the muddy water running over the floor board and within two inches of cameras and films in the back. A storm was coming up; things looked black indeed because those washes can rise five feet in fifteen minutes. We stripped and moved everything out of the car onto a high bank. [With the help of a large state truck] we just did get the car out; timed almost to ten minutes! . . . Breathed a vast sigh of relief when we struck the pavement in Colorado. Never such a trip! We have only 4000 more miles to go!!

From a letter to Beaumont and Nancy Newhall,
Mesa Verde National Park, Colorado, October 26, 1941

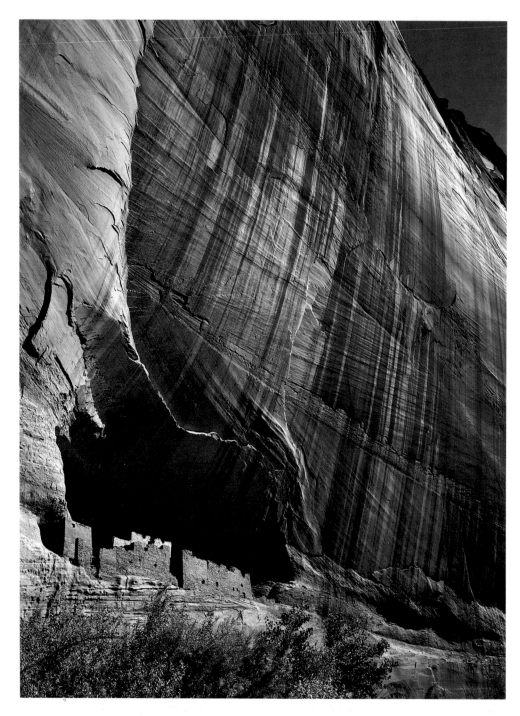

White House Ruin, Canyon de Chelly National Monument, Arizona, 1942

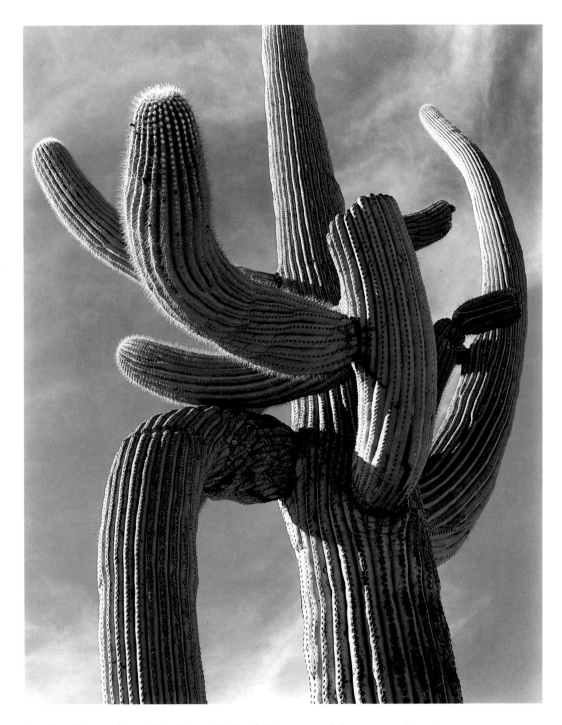

Involute Cactus, Organ Pipe Cactus National Monument, Arizona, c. 1948

I am gradually becoming impressed with the Carlsbad Caverns; but they are so strange and deep in the earth that I can never feel about them as I do with things in the sun — rocks, trees . . . surf and fog. The photographic problems are terrific; I start with a basic exposure of about ten minutes (figured on the basic light provided by Mazda and the National Park Service). I then boost up the image and "drama" with photoflash. Some of the forms are beyond description for sheer beauty; textures and substance are not so important as the formations are white and cream-colored in the main.

Twice a day I ride down in the elevator (just like an office building) for 750 feet, and then walk a mile through the caverns to the selected spot. I have not yet completed the smaller rooms — will tackle the Big Room (about two miles around) tomorrow and Friday.

From a letter to Patsy English, December 2, 1936

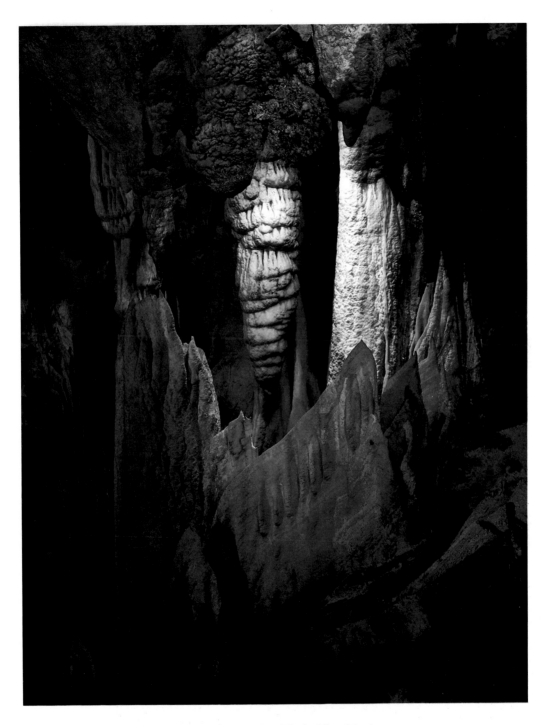

Detail, Papoose Room, Carlsbad Caverns National Park, New Mexico, c. 1942

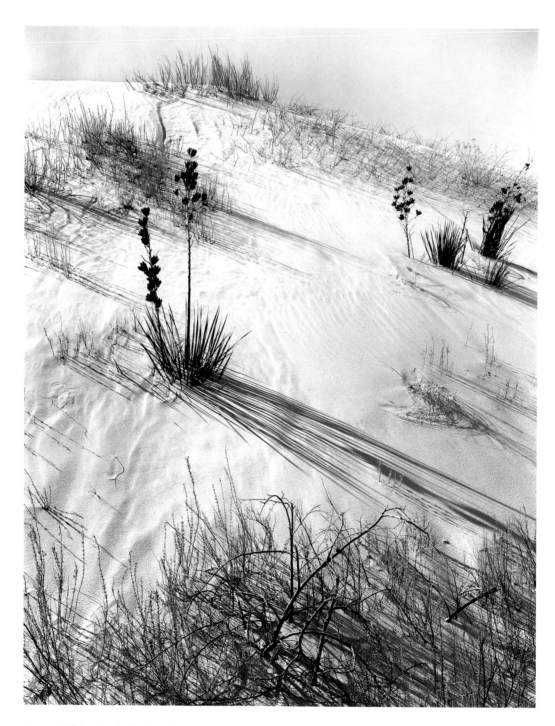

Dune, White Sands National Monument, New Mexico, 1941

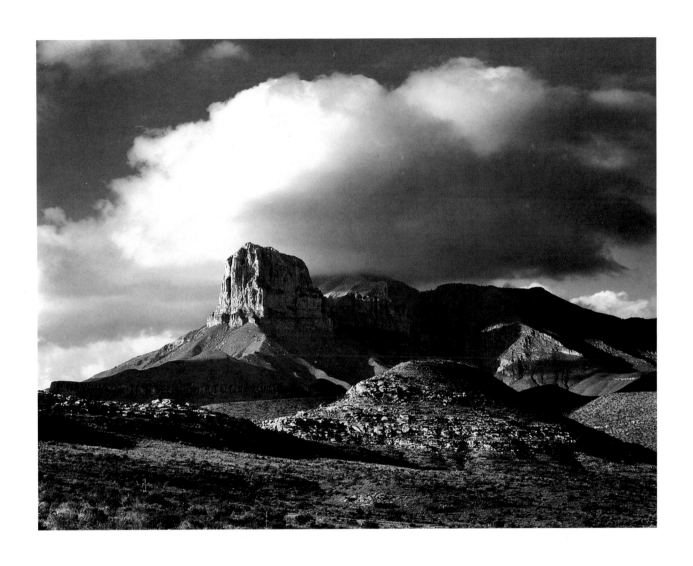

El Capitan Peak, Guadalupe Mountains National Park, Texas, 1947

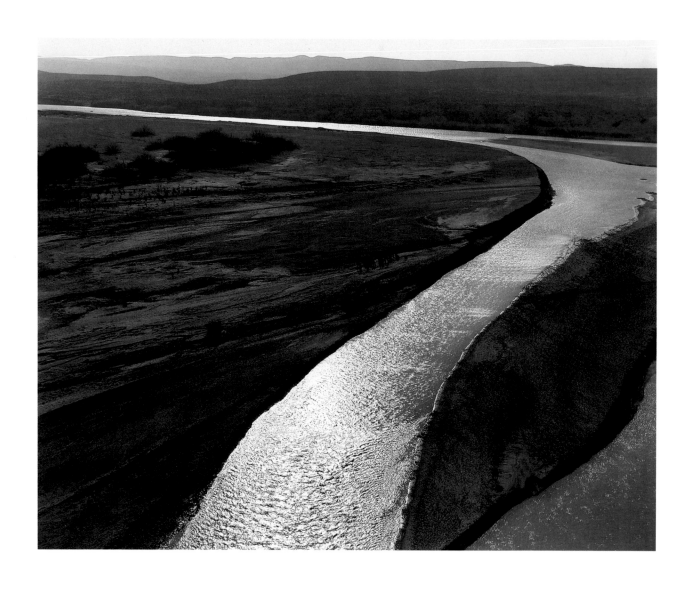

Sand Bar, Rio Grande River, Big Bend National Park, Texas, 1947

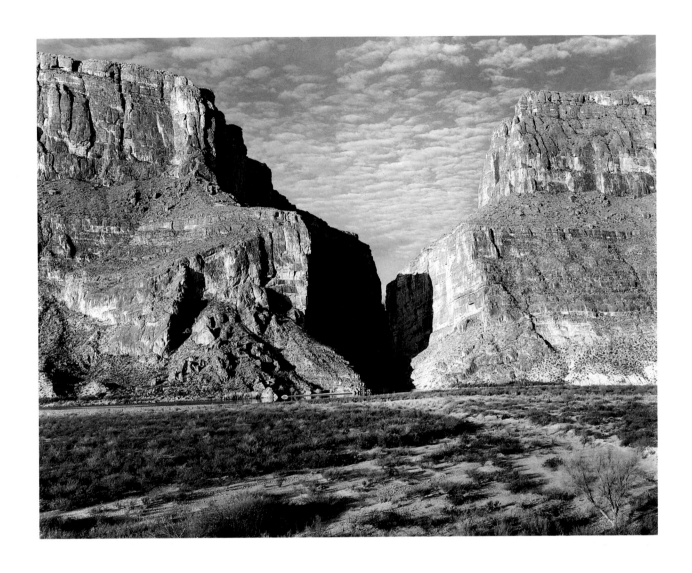

Santa Elena Canyon, Big Bend National Park, Texas, 1947

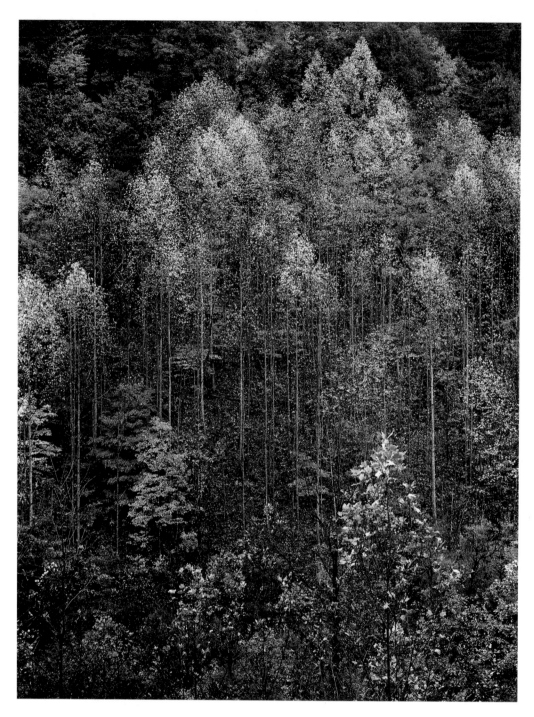

Dawn, Autumn, Great Smoky Mountains National Park, Tennessee, 1948

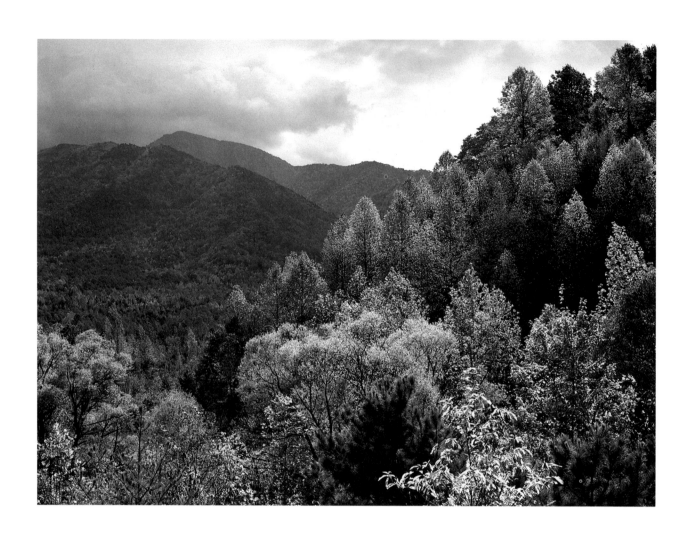

Mount LeConte, Autumn, Great Smoky Mountains National Park, Tennessee, 1948

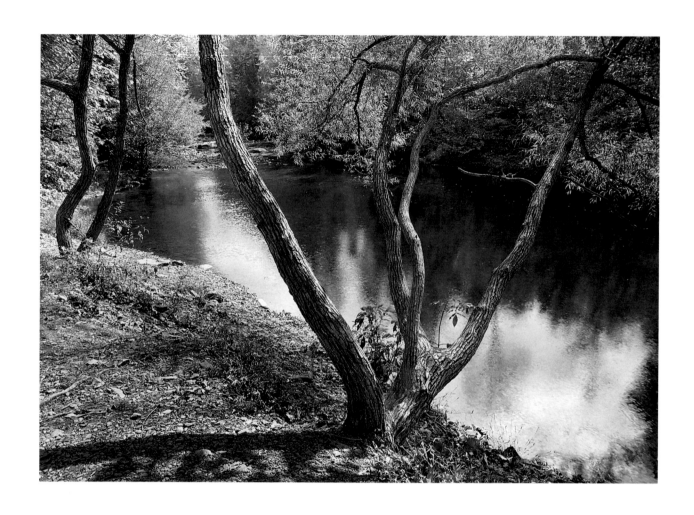

Stream and Tree Trunks, Autumn, Great Smoky Mountains National Park, Tennessee, 1948

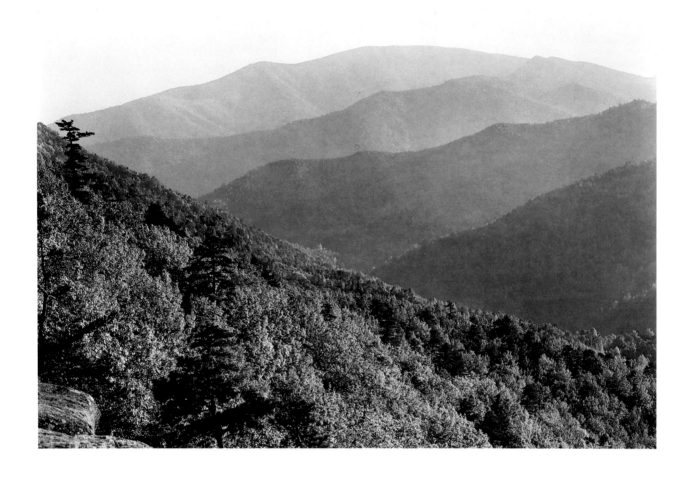

View from the Road, Shenandoah National Park, Virginia, 1948

Wilderness, or wildness, is a mystique. A religion, an intense philosophy, a dream of ideal society — these are also mystiques. We are not engaged in preserving so many acre-feet of water, so many board-feet of timber, so many billion tons of granite, so many profit possibilities in so many ways for those concerned with the material aspects of the world. Yet, we must accept the fact that human life (at least in the metabolic sense) depends upon the resources of the Earth. As the fisherman depends upon the rivers, lakes and seas, and the farmer upon the land for his existence, so does mankind in general depend upon the beauty of the world about him for his spiritual and emotional existence.

From a speech to The Wilderness Society, May 9, 1980

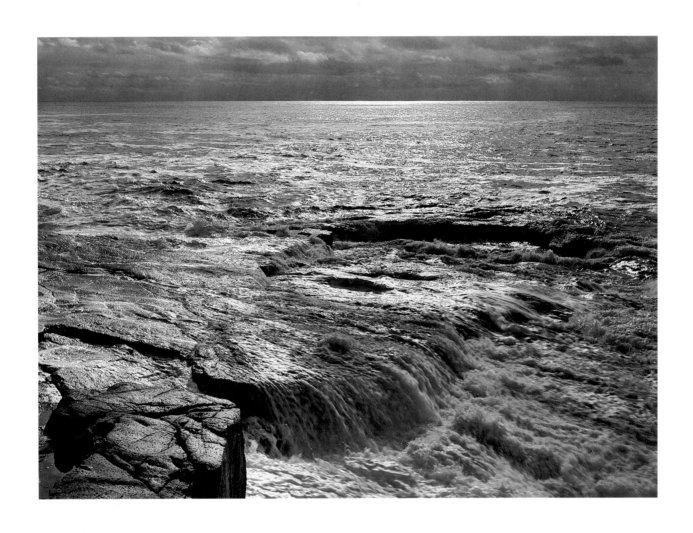

The Atlantic from Schoodic Point, Acadia National Park, Maine, 1949

Selected Writings by Ansel Adams

Introduction, 1972 Sierra Club Engagement Calendar:

On the National Parks

One hundred years ago a great concept was born, unique to our democratic society and directed to the benefit of all classes of people: The Yellowstone region was set aside as a great national park to celebrate and protect the "wonders and curiosities" of nature. This was all the more remarkable because, in those early times, there seemed to be an inexhaustible wealth of wildness and a very small population to invade it. A prophetic vision hovered over that historic campfire in the Yellowstone in September, 1870, when Judge Hedges of the Washburn-Langford party proposed "that there ought to be no private ownership of any portion of that region, but that the whole of it ought to be set apart as a great National Park. . . ." President Grant signed the park into existence on March 1, 1872. The national park concept has endured for a century in spite of the pressures of resource exploitation and irrational demands for inappropriate use by the very people for whose benefit the national parks and monuments were set aside. But let us never forget that the National Park System is based upon a legislative act (the National Park Service Act of 1916) and is not securely incorporated in the Constitution of the United States. Hence, it is vulnerable to erosion and destruction by legislative action. Such action may be sudden and catastrophic, as in the event of some great national emergency, or it might appear as a slow but tragic attrition induced by overpopulation, economic pressures and public apathy. Obviously, "eternal vigilance" must therefore be the essential attitude of all our people.

We are faced today with a profound dilemma: How can our people and their children — to whom the parks and wilderness areas rightfully belong — experience their beauty and wonder and yet preserve these intrinsic qualities? The great natural shrines such as Yosemite Valley must be accessible to the public. John Muir once said to William E. Colby in Yosemite, "How wonderful it will be when a million people can see what we are seeing!" Millions a year *have* seen it and millions more will experience it in the future. The problems of appropriate use and management are clearly colossal. The vast wilderness areas within the parks are especially vulnerable to exploitation. Hence, restricted use of wild areas must be thought of as *protective* and not as a means of excluding those who fail to qualify as mountaineers.

Wilderness protection demands creative sacrifice on the part of all of us, and this sacrifice can be clarified and ennobled through education and the provision of nature-experiences for the young. Considering the earth as an isolated entity in space, we are not at liberty to overlook any part of it or any of its limited resources. When the Yellowstone Park was conceived, the environmental perils which plague us today were unknown, especially in the vast and lonely domains of the American West.

Today we must realize that nature is revealed in the simplest meadow, wood lot, marsh, stream or tidepool as well as in the remote grandeurs of our parks and wilderness areas.

The urban child, raised on concrete and under poisonous skies, is not conditioned for the magical experiences of the natural scene. The secret of preserving the national parks and wilderness lies, therefore, in direct contact and experience with nature in its simplest forms by the young children crowding upon us as the generations advance. Without this early experience as a child, a person cannot be expected to respond sympathetically to the natural world about him — or to all that the

natural world implies. Hence, as much natural beauty as possible must be introduced into urban and rural environments, and what already exists must be protected to the utmost. With nature nearby, we may then be better prepared to appreciate and protect those great dedicated areas of the National Parks.

LETTER TO NEWTON DRURY (FORMER
DIRECTOR, NATIONAL PARK SERVICE; AT TIME OF THIS LETTER,
DIRECTOR, CALIFORNIA STATE PARKS), JANUARY 22, 1952:

. . . I don't think I am a "stuff" or an idealistic crackpot. I may be, but I am not conscious of it! However, the National Park idea (in relation to primeval parks) is to me a very definite religious idea. That is the only way I can put it, although I know that semantically it does not make sense.

Over the years I have been inquiring of my own soul just what the primeval scene really signifies. I attempted to set these thoughts down in my National Parks Book [*My Camera in the National Parks*, 1950]. To me, the only valid meaning is one not related to recreation or to any physical aspect. Of course, by "recreation" I refer to the more obvious resort activities — not to activities related to hiking, climbing, camping in the wilderness, etc. In the final analysis, Half Dome is just a piece of rock — and what prevents water from flowing downhill? There is some deep personal distillation of spirit and concept which moulds these physical earthly facts into some transcendental emotional and spiritual experience. It is in this spirit that I believe. I cannot accept the idea that the great aspects of the primeval scene can be diluted with superficial experience — any more than a great work of art can be diluted and retain its primeval integrity.

Over the years I have seen an insidious decay of the primeval qualities of Yosemite. No one person or group can be accused in this; it represents a national attitude of exploitation and a national lack of spiritual appreciation. The time will come when we will wake up — and then there will probably be a frantic "restoration" of Yosemite (a kind of natural Williamsburg)! Every time I observe a tepid and flippant attitude towards the primeval park scene I have the same resentment that I would have were I to hear a Bing Crosby song in a great cathedral. I know I am visionary in this, but I feel it deeply.

I think there are no "common" people except as they are made common.

I have had most sympathetic response from people in all walks of life on the spiritual concept of the Parks (the primeval areas). But, as the emphasis on the purely recreational-profit-taking aspects have been stressed both by the Concessioners and the Park Service (the latter, and perhaps the former, too) on an unconscious misinterpretation of "public service," I find myself in an attitude of gentle belligerency because I know quite deep in my heart that, no matter how thin you slice it, it is still exploitation.

Were I "in power" the first thing I would do would be to make a sharp distinction between areas of ordinary recreation and areas of primeval spiritual potential. I would throw the money-changers out of the temple in the latter, and "invite them in" in the former categories.

I would not temporize with the higher realities of the spirit.

LETTER TO HAROLD ICKES (SECRETARY OF INTERIOR),
NOVEMBER 21, 1945:

Now that normal conditions of travel confront us and all signs indicate a tremendous utilization of the National Parks and Monuments, I desire to express my hope that Reclamation projects — such as Shasta, Boulder, Friant and Bonneville — will be developed as recreation areas in which facilities and activities of "resort" character will be emphasized.

I believe that the development of resort activities at these artificial lake areas would do much to alleviate the pressure on the National Parks, and open the way for a logical and strong emphasis on Park ideals and functions.

My constant, direct contact with Yosemite causes me to fear that unless some definite action is taken very soon to maintain the integrity of the National Parks a large amusement and resort development is certain to take place therein. Wherever I go I am aware of a rapidly growing desire for more roads and deeper penetration of the wilderness. These predatory motives appear in well organized groups perhaps more than in individuals, but I feel that the individual must be approached with a clear and dignified presentation of the peril confronting a valuable aspect of the National life.

I am certain that thousands of far-seeing persons would actively support the idea of concentrating resort activities in the great reclamation areas, thereby protecting the National Parks from disastrous exploitation.

FROM "INFORMATIONAL NOTES ON THE NATIONAL PARKS AND MONUMENTS," MY CAMERA IN THE NATIONAL PARKS, 1950:

. . . The first phase of the development of the Parks has been largely controlled by the requirements of public services which have in many instances (and with constructive intentions) dominated planning and interpretation. The final phase will see the complete adjustment of the material and spiritual aspects of the Parks to human need, with full emphasis on the intangible moods and qualities of the natural scene. In that happy day we hope the public will be self-screened; those who prefer the wilderness aspects of the world will be able to find them within the National Parks; they will visit the Parks for the purposes for which they were originally intended. This is not a philosophy of arbitrary exclusion; it is a philosophy of appropriate use for the benefit of our land and our citizenry, now and for generations to come. . . .

The argument is frequently presented that as we are a democracy we must accept the desires of the majority in everything relating to the public interest and the public domain; decisions must always be based on the precept of the greatest good for the greatest number. However, we cannot overlook the fact that in a true democracy the rights of the minority are also protected. In addition, the "greatest good" does not imply the greatest exploitation. It is fully apparent that important minority rights are recognized in various aspects of our national life. We do not permit juke-boxes in the halls of the Library of Congress, peanuts are not sold in the aisles of our cathedrals, cigarette advertisements are not displayed in the National Gallery of Art. The sanctity of a church, a gallery of art, or a great temple of Nature depends upon appropriate use.

FROM "THE ROLE OF THE ARTIST IN CONSERVATION," 1975 HORACE ALBRIGHT LECTURE (THE UNIVERSITY OF CALIFORNIA, BERKELEY):

. . . In the great existing domains, such as Yosemite, Sequoia, Glacier, and Yellowstone there will always have to be small "enclaves" for public service but the largest areas should be on the Reserve or Preserve status. Yosemite Valley is a great national shrine; I do not think it is possible, or appropriate, to contemplate removing all services from it. But the objectives of removing all automobiles from the Valley and *most* of the services are completely commendable. . . .

Exclusion is, for me, a bad word indeed. I want people to *experience* Yosemite and the Sierra. . . . *To experience* need not imply *to destroy.* For a few hardy souls to demand the sealing off of the wild places represents a brutal policy I cannot condone. I am anxious, however, to promote the essential controls that will limit use so that, in the classic words of the law, "the land will be inalienable for all time." The problem is to replace the Curious with the Wonderful, de-emphasize recreation in favor of the re-creation of the spirit, encourage perception, realization, and creation. Any artist in search of a theme has two that are set out clearly before him: the interpretation of the environment and the interpretation of man's relationship to it.

The artist and the photographer, especially among the young people of our time, seek the mysteries and the adventures of experience in nature. The National Parks should be totally inviting: free of the complex jangle of cash registers, the auto horns, and the crowding of confused flesh. The basic mood must always be protective of the area and create respect and affection. Because I have reached the age when I cannot climb and scramble as I was wont to do in my remote past, does not encourage me to promote roads, trams, or helicopter services into the wild places. I would like to think of all young people of today, with their health, vigor, and creativity striding the high hills as I did so many years ago, with the beauty and the wonder of the world opening before them.

Plan for National Park and Wilderness Areas

Zone of Anticipation
Zone of Appreciation
Zone of Experience
Zone of Isolation

From Adams' Foreword to *Words of the Earth* by Cedric Wright (photographer, musician, Adams' closest friend, and Sierra Club High Trip companion in the 1920s and 1930s), 1960:

. . . It is true that Cedric [Wright] employed symbols to explain symbols — but what more can art in any form accomplish? The mood and actuality of a crisp Sierra dawn over a glittering meadow should be experienced by all our people — living here in the shadow of the Sierra as well as in the labyrinths of Chicago and New York. Towering granite peaks and rolling thunderclouds over a high-mountain lake are part of our basic heritage; many of the trapped urban millions may find it difficult to gain direct experience of wild places, but the creative intensity of art can bring them some of the magic and mystery of nature and encourage them to think, to dream, and perhaps to explore. The realities and bounties of nature are as actual as the urban and rural realities of our society, and may be recognized as such and accepted when experienced directly, or through some intense creative-emotional interpretations. Cedric believed that any man's spiritual horizons would be expanded through contact with nature, and his life was dedicated to this idea.

From "Problems of Interpretation of the Natural Scene," *Sierra Club Bulletin*, 1945:

I believe a philosophy of appreciation has taken root in the consciousness of the American people. Even though distorted by the false emphasis and exaggerations of commercial exploitation and advertising, the *facts* of our magnificent land are nevertheless slowly rising above the tides of confusion. Now as vulnerable as the first seedlings after rain, they may in time become firm elements of our national life — but only if we nourish them and expand the positive directions of their growth. The sum of our *response* is the sum of our experience of myriad minute actualities and forces; the sum of our *appreciation* lies in the mood and understanding that we bring to these intimate experiences.

One weakness in our appreciation of nature is the emphasis placed upon *scenery*, which in its exploited aspect is merely a gargantuan curio. Things are appreciated for size, unusuality, and scarcity more than for their subtleties and emotional relationship to everyday life. Even some of the most sincere proponents of the National Parks speak of "the oldest living thing," or "the highest waterfall," or "the greatest collection of geysers in the world," unmindful that such extremes are merely coincidental and have little to do with true spiritual and emotional values. The moon rising beyond a great mountain establishes an emotional actuality which has nothing whatever to do with size, distance, or coincidence. Likewise, common grass growing against stone may be of more poignant beauty than an entire grove of sequoias in their most conventional "tourist" aspect....

The imposition of commercial "resortism" violates the true functions of the National Parks. Our expectations of the Parks are largely formed by the resort-colored interpretations of the travel folders; the pleasures of the day overshadow the eternal pageant; the great mountains and forests become mere backdrops for a shallow play. Pure physical recreation (which certainly works no harm if in appropriate balance) aside, the only value of most national park and wilderness areas is *the value of the intangibles*.

Every person would rise in indignation were he to observe careless destruction of marketable timber, flooding of mines, or poisoning of lakes and rivers. Any tragic waste of our natural resources would arouse alarm and protest. But now let us pause and think — are not the intangibles of the natural world an integral part of our national resource? And are they not of incalculable importance to the development of our civilization and to the generations to follow us? Can we let them be wasted?

We must fight for *integrity of experience* as well as for the more obvious benefits of existence. We are confronted with a terrifying danger to the Parks and to the Wilderness, and to all that they represent in our culture and way of living. Predatory

interests desiring to enlarge their rightful share of the natural resources clamor for additional exploitation and invasion of these preserved areas, and for the limitation — if not actual rescinding — of important new designations.

The huge and aggressive business known collectively as *Travel* is a more dangerous adversary than all the oil, lumber, cattle, and mining interests combined. The large and confused public opinion on the prime functions of the areas under discussion further complicates the problem. Our object should be to define the character and appropriate use of all the regions known as "naturalistic" so that their values will remain unimpaired for generations. Controlled use certainly does not violate any fundamental precept of Democracy. . . .

LETTER TO NEWTON DRURY (DIRECTOR, NATIONAL PARK SERVICE), OCTOBER 24, 1944:

. . . In order that the National Park Service fully protect and interpret the National Park Idea and the Parks themselves the Service will be obliged to undertake an extensive program of education and interpretation throughout the country at large. This should be designed to prepare the citizen — factually and in regard to concept and mood — for an appropriate experience in the Parks. This will be a very expensive undertaking, but it is the only way to counteract the dynamic exploitation of the commercial interests. The Parks are largely interpreted today (pre-war years) through the advertising and promotional literature of the operators and transportation concerns.

In addition to external preparation, the problem of interpretation within the Parks is very important. The Museums and Park Naturalists are doing a fine job in the main. But, again, the operator [concessionaire] wields far too much power with the visitors to be neglected. Hence, I recommend the establishment of a "National Parks Institute" (this is not necessarily the proper title) designed to appropriately indoctrinate every person who serves in direct contact with Park visitors. This would include Rangers and other Park employees, Executives, bus drivers, information clerks, advertising and publicity men who are employed by the various operators. If I joined the Navy I would be obliged to take an indoctrination course before I could function in any officer capacity. This would simply be to assure my knowledge of what the Navy is, how it functions,

and to further assure my intelligent cooperation. For every dollar the Park Service spends in promoting the Park idea, the operators spend perhaps one hundred dollars promoting the *resort* idea, not only in direct advertising, but in internal emphasis on secondary amusement factors. Unless this is effected in some way within the near future I feel confident we shall witness a gradual deterioration of Park aims, and the ascendency of exploitational principles.

LETTER TO JOHN PRESTON (SUPERINTENDENT, YOSEMITE NATIONAL PARK), JULY 5, 1961:

I have a very strong feeling about signs, because I think there is some quality of magic in the out of doors which is lost if it is turned into too much of a museum mood. Not that the signs are not sometimes of great value in certain areas: as I said, at the Olmsted View turn-out I think the signs really help in giving a rather inclusive informational awareness of the great view. I also do not object to signs such as the geological sign down the Merced Canyon or the Exfoliated Granite sign in the cut, but I do think that as we pass true nature we should be brought out into it rather than find it "crystallized" as a fact that has been classified and labeled. This is very difficult to put into words. I completely agree with you that signs . . . help from an informational standpoint, but my question is as to whether the actual value of information is as important as the subtle quality and mood of the natural scene all by itself and as it is "discovered" by people. For example, the little lake to the south of Tioga Pass to my mind needs no designation whatsoever. In fact, informational designation in such a case simply intrudes on the very magical scene which can mean many things to many people. I think the place for such information is in a little folder or a book, or perhaps definitive informational plaques at obviously key assembly points.

LETTER TO DAVID BROWER, ET AL. (SIERRA CLUB), APRIL 5, 1955:

I have your note and the enclosure re: the "modern" architecture at the Grand Canyon. For quite some time I have been intending to express myself about the whole unfortunate mis-

conception of "modern" architecture in relation to the Parks. I don't think I can get into a philosophical discussion here which would arrive anywhere in particular, but I would like to pose a few questions which I hope can be thrashed out in detail later:

1ST. What is Modern Architecture?

2ND. Why should we perpetuate the "log-cabin" spirit?

3RD. How can we use the best brains and genius to create appropriate environments in the Parks?

We opposed the Wright Dome in Yosemite not because it was "Modern Architecture" but because it was inappropriate, dominating architecture. However, I would prefer the Wright Dome to the Ahwahnee, to El Tovar, to the new Teton Lodge (a horror from its pictures!). I resent the sentimental "rustic" abortions, the commercial shacks, the affected palaces of the usual Park Headquarters, and the general fusty gloom of "Park" design. I think we need "modern" architecture, but GOOD modern architecture.

I have always labored under the conviction that, as the Parks and the Wilderness express the heights of inspirational experience in terms of nature — that anything Man does therein should strive to match the heights of emotion, inspiration, and creation suggested by the Natural Scene.

We have, instead, soupy writing, sloppy planning, goofy concepts of art, architecture and decoration, incredibly bad souvenirs, and a hang-dawg mentality about it all that chills the marrow of the spiritual bones!!!!

What the Parks need is the Best Modern Architect in the World, and the Most Resolute Uncompromising Director, and the most enlightened Public Opinion. We have suffered too long with the kind of thinking that favors corn because of some sentimental hangover concept that crudeness is the equivalent of spirituality!

I wish we could have a really hot symposium on this very important subject! We have to get people to realize that Rome is burning in many places at once!!!!

LETTER TO DAVID BROWER (EXECUTIVE DIRECTOR, SIERRA CLUB), FEBRUARY 15, 1956:

Your letter of 2/13 is much appreciated. I am glad to see you still have the old rise! Either you missed an important point or I failed to make it, to wit: I don't want ANY architecture in the wilderness!! I believe in trails, walking, sleeping bags and caves under rocks. I am not talking about "wilderness" in reference to architecture. . . . I am talking about the stuff that people think must be built in those parts of the Parks which are not wilderness, but have been made into natural cash-registers; in other words, Yosemite Valley, Yellowstone, etc. But where buildings "have" to be built (and you know how I feel about that — there are too many buildings everywhere) I would rather see the kind of building which was the "leastest" building in terms of visual impact.

Steel, Glass and Plastics do possess, I admit, for some people connotations, but that is their fault. The kind of structure I envision could be removed from the scene much faster than a log cabin! The Log Cabin has connotations — to me they are not good. The Log Cabin represents trees cut down. The rock building bothers me because it is a hell of a job piling up a lot of rocks — unless they are put together well they may collapse and hurt you — and they are awful hard to move. The mobile structure I speak of is, to my mind, the least destructive, the least obtrusive, the easiest moved, and the most functional. If properly designed it would be scarcely visible. . . .

To be consistent, Mr. Olmsted should have suggested that, when he got to the trail he would divest himself of shoes — then of watch, pen, pants, etc. Naturally he would NEVER have carried a gun — so he would have to fashion a club or spear in order to get enough to eat (I trust his falsies fitted well enough to tear raw meat). He would then have to eliminate a certain amount of wildlife, pull up a certain amount of plants for the roots, pick a lot of berries (if any available) — and, in time he would either fall prey to a hungry mountain lion, or would have to be rescued by an army of rangers (at considerable cost to the Government and some rough use of the terrain).

The wilderness is not wilderness unless it is reasonably pure: unfortunately, in order to keep it pure we have to occupy it (even in a negative sense). I fear a lot of the wilderness reaction is one of specific personal escapism — but we really do not escape from the realities of life and civilization. We enjoy the wilderness *because* of the advantages of civilization. If I were a dictator, my decrees would please you no end — simply because I would really cut off vast areas from any form of development, even, sometimes, trails. But my argument relates to the kind of structures I think are logical where structures apparently HAVE to be (and I don't agree that they HAVE to be

anywhere 70% of the time). I certainly feel that the gangrenous pile of the Ahwahnee, and the cute Winnie-Pooh-Throckmorton Abbey mood of the LeConte Lodge are vastly more obtrusive in form, shape and mood than would be a simple shelter of transparent, movable materials. I guess I just don't believe that many people come to the Parks to "escape" — they come for the experience of nature (a more positive approach). . . .

LETTER TO ROGERS C. B. MORTON (SECRETARY OF INTERIOR), JANUARY 1, 1975:

January 1 seems an appropriate day to extend warmest greetings to you and Mrs. Morton and also to make a few remarks intended to be constructive.

I have just seen a press clipping regarding the new Big Thicket National Preserve. I do not have the date of this clipping, but it is fairly recent.

I am naturally pleased that this National Preserve has been established.

It serves to stimulate my reason for writing about a matter which I think is of supreme importance in relation to the National Park Concept.

I believe semantics have much to do in the direction and comprehension of our affairs. The term "Park" has, for more than fifty years, bothered me because of the connotations of use and "enjoyment" (also a semantic confusion!) that lie in this term.

There is nothing wrong in the term itself — Federal and State Parks, Central Park, Golden Gate Park, etc., all are important and all presumably relate to "enjoyment" — recreation, relaxation, cultural attractions, ample public services, etc.

But the term PARK does not accomplish what the terms RESERVE or PRESERVE do in establishing some definition of use and, hence, some definition of "development." I can cite *Point Lobos Reserve* — there is no doubt at all what this signifies; the area is restricted in many ways and benefits greatly therefrom. This, in distinction to — State Beach Parks — mostly set aside for recreation, which is good. The Point Reyes Seashore is a fine example of both preservation and recreation (I think the first takes precedence in this case).

I feel that if Yosemite were known as YOSEMITE NATIONAL RESERVE it would be a relatively simple matter to control the activities and the "developments" therein. Certain "enclaves" of moderate development (now historically established) such as the Valley itself, could be put into a static development classification and Wawona more fully developed as a recreational center. Another enclave — Tuolumne Meadows — and the High Sierra Camps, probably have justification for quiet, continued existence about as they are now. Wawona is *not* of "preserve" character.

The greatest area of the "Park" should be irrevocably defined as Wilderness, or Wild, areas. I do not refer to "sealing them off" but to a restrained, logical use by riders and hikers. Such amenities as trails, simple bridges and sanitary facilities would represent the limits of "development." It would give me the greatest satisfaction to stand at Glacier Point (as every citizen should be encouraged and assisted to do) and view the Yosemite Reserve as it is today — without intrusion of roads, ski lifts, accommodations, aircraft (except rescue and essential service and protective systems).

LETTER TO EIVIND T. SCOYEN (ASSOCIATE DIRECTOR, NATIONAL PARK SERVICE), FEBRUARY 10, 1959:

. . . Personally, I think a powerful National Park Service should be built on a quite different structure than the one it now has. Legend has it that the old Irish kings held court with a knight on one hand and a poet on the other. This would not be a bad model! I think the Park Service should have a mandatory attitude of resistance to development — not one of capitulation to the pressures of exploitative planning. Let them resist every intrusion (of the wilderness areas): if the pressure is so great that they *must* respond, such response should be minimum and controlled. I think the Director of the National Parks should be an appointive post — he should be selected by the Secretary [of Interior] from the ranks of dedicated conservationists. Let the Associate Director run the Bureau; let there be inspection committees composed of representatives of the leading conservation, wildlife, and planning organizations, which would serve as paid groups to tour all the areas, examine all the planning, and report frequently to the Secretary. . . .

LETTER TO DR. HENRY J. VAUX (DEAN OF THE
DEPARTMENT OF FORESTRY AT THE UNIVERSITY
OF CALIFORNIA, BERKELEY), OCTOBER 7, 1960:

. . . It seems to me that most arguments pro and con on Mul-
tiple Use of forest areas, and the other categories as well, are
based on a materialistic concept rather than a concept which is
inspirational, related to "mood" and to the more important
aspects of the individual's existence, which, I firmly believe, are
emotional rather than physical. . . .

After many years' experience with park and Forest people,
with conservationists, with the kind of "do-gooder" who tem-
pers his principles to the wind of advantage and "financial
necessity," I have come ruefully to the conclusion that very few
know what they are talking about! I am distressed that so many
academic people fall back on the conventional security of terms
such as "management," or spice their arguments with references
to "population" increases, economic travel pressures, etc. It
seems to me that the whole business of wilderness preservation,
National Park principles, etc., is in a desperately dangerous
mess. I hope I am not entering the domain of the naive when I
state that the entire problem is an extremely simple one, and
that the values involved are simple values — with final and
conclusive meaning.

We either have wild places or we don't. We admit the
spiritual-emotional validity of wild beautiful places or we
don't. We have a philosophy of simplicity of experience in these wild
places or we don't. We admit an almost religious devotion to
the clean exposition of the wild, natural earth, or we don't.
Any management we find necessary — and may it be minimal
— can be effected without impairing the wilderness aspect and
moods. The cutting of trees under any circumstance would so
impair the mood. The development of roads and facilities ditto.
The spraying of the forests (such as the fiasco recently perpe-
trated in the Tuolumne Meadows area) ditto; I have seen three
bug infestations in that part of the Sierra, and the forest "sur-
vives" in a natural state of change and adjustment. I hesitate to
define just what the qualities of true wilderness experience are
— like music and art, wilderness can be defined only on its
own terms; the less "talk" the better.

The whole concept of multiple use is, to me, a shocking dis-
tortion of logic and of responsibility. "Management," unless

applied with respect and devotion, is nothing but carefully cal-
culated exploitation.

LETTER TO HORACE ALBRIGHT (SECOND DIRECTOR OF THE
NATIONAL PARK SERVICE, LONGTIME FRIEND AND CONSERVA-
TION COLLEAGUE TO ANSEL ADAMS), JULY 11, 1957:

I have been very remiss in not writing you before this. . . .

Within my capacity for legal understanding (slight) I have
attempted to take an objective view on the Wilderness Bill.
[The Wilderness Act, finally passed in 1964, created the national
wilderness system, providing designated lands with even more
protection than national park status. The protections of the act
were gradually applied, by Congress, to prime park areas,
though only after considerable resistance from the Service.]
Emotionally, I am strongly inclined towards any means to fur-
ther protect the wild places. This bill — and other important
legislation over the past decades — seems to represent a kind of
National Conscience — it is difficult, if not impossible, for the
layman to comprehend the legal and legislative complexities,
but he can (and does) respond to the underlying motivations....

I came to Yosemite first in 1916 (was 14 years old). Until
1929–30 I was actively studying music — then turned to pho-
tography. My life has been largely concerned with the interpre-
tive and expressive aspects, and I naturally have viewed the
National Parks and the wilderness through the eyes of an artist
rather than those of a scientist, politician, or administrator. I
have been returned to the Board of Directors of the Sierra Club
largely because of my "nuisance" value; certainly not because of
any ability in legislative and political fields! Over the years I
have seen the material values and qualities of Yosemite
"improve" and the emotional, "magical," and inspirational
moods regress. This is very difficult to put into words; it is
frankly related to the intangibles and can only make sense in
that domain.

I have always considered that the prime objectives of the
National Parks were to provide inspiration, self-discovery of
spirit in the wild places, and appropriate recreation. The princi-
pal parks and monuments are set aside and protected for such
human benefits — not for economic purposes. They are, in
effect, vast areas devoted to the development of the spirit and

for recreation in the true sense of the term. This concept places the National Parks at the highest level of an advanced civilization. With this concept as a guiding light, it is difficult to comprehend how exploitation and "development" of recent kind can be justified and it is unfortunate that the Service has become so large that it cannot dwell upon the prime problems — but must preserve its own operational momentums and *create* activities to keep afloat. What I am saying is, in effect, that the Service itself — its momentums, energies, political resources, and public relations — has become more important than what it was originally set up to serve — the parks and the park ideals and spirit. Everyone in the Service is trapped in the vast web-like machinery of operations, development, policy, and public contacts. With the best intentions the Service has, I believe, lost touch with the more subtle and fragile elements of its responsibility.

I am quite aware that there are vast legislative and operational problems which must be faced, that the increasing population pressures make the present more difficult than the past (and the future will be more difficult than the present). The parks belong to the people, but I believe it is the responsibility of the Park Service to protect and administer the parks for the people in terms of basic park and wilderness values, and not approach their responsibilities on the basis of selling the Service and the parks to the nation. . . .

I am always inclined to make comparison between the functions and administration of the National Parks and of the National Gallery of Art in Washington. Both are the property of the people of our country. The Gallery of Art exists as a most excellent depository and means of display of truly great works of art. It is there for all who *wish* to come. People are not sucked in by excessive publicity, or by extraneous activites and "entertainment." Nobody is making any profit — prestige or material — out of the National Gallery as far as I can judge. But many people and institutions are making profit out of the parks — operators, travel lines, peripheral businesses, etc. — and these exert pressure along the complex and typical pattern of influencing legislation, political and bureaucratic policy, and creating a public demand. . . .

. . . I do not believe in exclusion of anyone from the parks. But I do believe in what might be termed "natural inclusion" — the audience which is automatically attracted to the parks because of their intrinsic values — not the imposed entertainment values, or the values which are stimulated and augmented by publicity. I go to the National Gallery to see great paintings — the Gallery's function is simple and direct. But I go to Yosemite not because of the attractions of the Firefall, dancing, vaudeville and popular music, urban cocktail lounges and food services, hideous curios, slick roads, and a general holiday spirit — and somewhere back of this smoke-screen of resortism the real Valley can be seen (but usually through a thick haze of campfire and incinerator smoke). One cannot point out all of the aspects of resortism and condemn them in themselves; most are quite decent and valid (excepting the Firefall and the curios) by themselves, but are simply dominant at present in terms of the Yosemite experience for, I believe, the majority of visitors. They bear little relationship to the basic values of one of the most remarkable and inspirational places on earth. . . .

That is why I support the Wilderness Bill, and why I would support ANY bill that would serve to add protection, reduce exploitation (by business OR government), and aid in securing some positive remnant of true wilderness. I appreciate the pressures which the park and Forest Services constantly resist, and I am thankful that so many *are* resisted, but there may come a time when the pressures might well exceed in power all the resistances we can muster under the present setup. If any legislation would serve to aid in resisting such destructive pressures it should be supported by all sympathetic people. I may be quite naive, politically speaking, but I frankly cannot see why the Park Service should not leap at the opportunity for *support* of their actual functions — to preserve the National Parks in an unimpaired state for the people of the future. I fear, and this is said without personal rancor, that the Service is more concerned with the Service than with the Parks, and the Wilderness Bill needles their pride and their inherent need for dominance. I have seen no argument to date which has overpowered the basic potential value of the Wilderness Bill (although I can see how certain details might be better worked out, and better definitions made of basic meanings). Semantics should not retard action, however!

You see, I still believe in the fairies of mood and simplicity. And I think we are straying far from the appropriate paths in our frantic "developments" of the few beautiful wild places remaining in our land.

LETTER TO PRESIDENT DWIGHT EISENHOWER,
DECEMBER 28, 1953:

The recent decision of the Secretary of the Interior recommending immediate construction of the Echo Park Dam in Dinosaur National Monument constitutes a major national tragedy.

I cannot believe this decision indicates the desire of the Secretary or his advisers intentionally to invade and destroy a National Monument, but I strongly feel that it represents a most serious lack of understanding and appreciation of the significance and importance of the National Park System.

It represents negation of the fundamental principle of the American institution of the National Parks — which James Bryce described as our Nation's unique contribution to the democratic concept of Government. It clearly shows that the immense intangible values of the Natural Scene and the wilderness environment have not been adequately considered in the Secretary's decision.

For many years conservationists have spear-headed the National Parks idea. Illustrious men such as John Muir, Theodore Roosevelt, Stephen T. Mather, Horace M. Albright, Harold L. Ickes, William E. Colby and many others of both conservative and liberal persuasion have devoted their imagination and energy to the establishment of the National Park System and its interpretation and operation for the benefit of the American People. The true measure of a civilization lies not in its mere physical and practical accomplishments, but in the achievements of the spirit and in the protection of spiritual and inspirational values.

The essential values of the National Parks immeasurably transcend their material potentials such as dams, mines, lumber, grazing, and resort enterprises; they rest only in the priceless and profound qualities of natural beauty and wilderness moods. These qualities increase in importance as our population grows and the physical exploitations expand. The disastrous precedent of the Echo Park Dam — if approved — must be clear to all, especially to those entrusted with the sacred obligation to preserve and protect the established National Park System. This precedent is all the more dangerous because of the fact that alternate and superior locations for dams exist in non-scenic areas of the same general region of Colorado.

I implore you as President of this great Nation, to use your vast prestige and humanity to reaffirm the inviolate character of the National Parks concept, and to urge Congress not only to disapprove the Echo Park Dam, but to plan further legislation to assure the integrity and security of the National Parks and their incalculable importance not only to us but to the generations that will follow.

LETTER TO EDWARD C. HARDY (CHIEF OPERATING OFFICER, YOSEMITE PARK & CURRY COMPANY), MAY 17, 1976:

. . . First, I want to clear up some points of importance. They may suggest a clarification of my basic concepts of the National Parks and their relation to our citizens.

1. From about 1920 I have had a consuming interest in the meaning of the National Parks and, as you must know, a great interest in "operations" — both government and concessioner.

2. I have ALWAYS believed that private business is questionable in terms of "controlling" the public services in the National Parks. To be more precise, I would say that the *concept* of this management is wrong: some concessioners have tried sincerely (and with good effect) to give appropriate service. The basic structure of the capitalist system (which has been successful in many ways in the private sector) is a dichotomy in the National Parks. I would be the first to agree that any business of scope and responsibility would *have* to consider its own continuance — and the expansions and consolidations implicit in its need for meeting costs and making a fair profit.

3. I have always maintained that IF a business is invited into the park, it must be allowed to conduct itself as a business. It MUST meet its costs and it must realize some income and security. My basic question is simply this: does a private enterprise *belong* in a park and can it ever function in an ideal sense? I frankly do not think it is possible.

4. The *status quo* versus the theoretical ideal seems to be the crux of the acrimony. I assure you, I never contemplated a sudden eviction of the concessioner, nor his removal without "due process." I assure you, I do not sit around gloating over the possibility of slaying dragons or engaging in a personal vendetta. Over the years my relationship with the staff of YPCCO has been cordial and, in the main, constructive.

The fact that none of us should be *in* Yosemite as concessioners does not cloud my objective approval of good service and a sincere effort to serve the public. This may be difficult for you to understand, but I assure you it is the truth.

5. When I have often stated that I believe Yosemite to be more beautiful and well-managed, I am primarily referring to the Park Service, which maintains the area in a clean, well-ordered way. YPCCO has undoubtedly assisted in this and is to be *commended*. . . .

I think it is simply this: you ARE in Yosemite on the basis of the present concessioner system (and under government regulations, limitations, etc.). I would say that you are doing an appropriate job — as you should be doing. This is an entirely different matter from my basic theoretical concept that we ALL should NOT be in Yosemite. And this includes The Ansel Adams Gallery! . . .

LETTER TO ROBERT E. WILSON (JOURNALIST), APRIL 4, 1976:

. . . I have no love for MCA (and I had no love for prior concessioners!) but, since the founding of the NPS there has been a *de facto* relationship of "business" to the Parks. Mather invited business into the Parks with naive confidence that business would do a good job, keep Park ideals in mind, and make a small, fair profit. He was a fine, trusting and rich man. He made a great contribution through the National Park concept.

It was soon apparent (I would say around 1925-6) that any business in the National Parks would have to protect its interest by expansion and provision of "amenities." Investments demand "profits." Unless we have charitable and "tax-loss" motives as basic policy any "business" must make money — or go bust. The concessioner industry, with quite logical motivation, deemed themselves essential to the functions of the Parks in relation to the people. In their eyes, "public service" (the profit variety) became an abiding obligation. And this obligation was nurtured by the NPS over many decades. Obviously the NPS had no other answer to the problem (excepting a few strange semi-government "operations" that never seemed to get into valid position). The Parks were there; people came to them; people had to be housed and fed (and sold horrible curios) and "entertained." (The Natural Scene was not enough, of course; the evenings were bleak — "gotta keep full of fun, man!!")

With VERY few exceptions the Park Service was populated with good, dull "public servants" without imaginative force (and little opportunity to express it if they had it). However, the Park people (with the conservation organizations mostly back of them in principle) did try to carry out the prime mandate. But time and again (and I saw a lot of this in the 1930s and 40s and 50s) the concessioner would go over the heads of the Superintendents and the Regional people directly to the Secretary (if the Director failed them) and on to Congress. And they usually got what they wanted. Such is the structure of American Government. . . .

What I am trying to say is this: the Concession situation was initiated by the Park Service and has been continued by them and with demands upon the concessioners for public service that created their commercial emphasis as a matter of survival. I do not forgive the selfish and stupid attitudes so often encountered with the concessioners. But I do feel that they function at a basic disadvantage and, to be completely fair, I do not think we can overlook this. In truth, if we do overlook it we are not giving the accurate "picture" of the whole situation.

The National Park Service really must take the blame for the situation as we now have it. I think this should be the basic theme. Without forgiving the acquisitiveness of concessioners I think we weaken our position by putting the entire blame on them. As a business man, in the position of a concessioner, would you not expect to "influence" a "Master Plan" to your advantage? Believe me, it has been done many times! The NPS has no power to refute this influence. I think that any Director of the NPS (except one functioning under a Secretary of the Interior such as Harold Ickes) would be powerless. It would mean a drastic change of basic policy (and one that would be resisted in Congress).

Hence, to sum up my thoughts:

1. The capabilities of the Concessioners are directed towards their self-preservation and continuation. This comes first; in some instances we have evidence of concern for the Park concepts — but not much.

2. The Park concept is limited to inherent qualities of the Natural Scene and to making it possible for citizens to participate in the experience.

3. The experience has never been defined in terms of the general public.

4. The Park Service has, at present, no alternative to the concessioner situation. Any action by the NPS to totally control the Concessioner would probably result in the latter's extinction or withdrawal.

5. What would that involve — politically and in terms of visitors' demands and expectations? It would be a mess of extraordinary character!

Again hence:

1. The only solution I see is for the NPS to completely and irrevocably take over all concessioner operations. I do not know if the NPS could actually administer the operations in detail but they might *lease* valid operations under strict control (where have I heard "strict control" before?). We assume some "operations" are valid.

2. I see the NPS as the sole arbiters of use and service and, of course, of "plan." The latter sounds fine, but the selection of *planners* is one of the really difficult tasks — especially for a government body.

3. *If you are to accuse any "body" or organization for the present situation in Yosemite I think you must first put the finger on the NPS.* This in no way condones the opaqueness and selfishness of MCA or any preceding concessioner. But the attack should be directed to where it belongs — right in the core of the NPS and the political and Bureaucratic institutions. . . .

STATEMENT ON THE TYPES OF CURIOS APPROPRIATE TO THE NATIONAL PARKS (WRITTEN AT THE REQUEST OF ARTHUR DEMARAY, DIRECTOR, NATIONAL PARK SERVICE), APRIL 1938:

Discussion on this subject should relate, first, to the definition of the cultural potentials of the national parks, and second, to what the public expects in the national parks, and how this demand may be met satisfactorily.

Primarily maintained for the preservation of natural objects and wildlife and for the benefit of the general public in the enjoyment and appreciation thereof, the national parks also contain a vast potential of cultural and aesthetic values, as yet but slightly developed. In other words, the park areas of the public domain, in addition to their main function, may provide cultural benefits of varied character, related to the environments in both representative and interpretative forms.

These cultural benefits may be integrated somewhat as follows:

1. Educational.
Ranger-Naturalist services, museums, libraries, botanical gardens, geologic and archaeological exhibits, and general field educational work.

2. Spiritual.
Contemplation of the natural scene with the complex personal connotations — emotional, religious, aesthetic.

3. Physical.
Hiking, climbing, riding, fishing, swimming and other related activities.

4. Social.
The relation of the individual to his Government — his awareness of his "partial possession" of the parks for his enjoyment and benefit. Also, the comradeship of others who are, in the park environment at least, sympathetic.

5. Aesthetic.
The direct aesthetic stimulation derived from contact, under favorable conditions, with the natural scene. Also, the stimulation of the aesthetic attitude in a general sense derived from the experience and the physical and mental rehabilitation resulting from contact with the natural scene. . . .

Public Service includes pictures, postcards and souvenirs just as much as it relates to rooms, meals, stores, garages, etc. The individual derives experiences from the parks while he is in them; he also desires to take something tangible from them as a memento of his experiences. He buys a painting, a photograph, a book, or a "curio."

These "curios" are significant to him; as an average individual he may not be expected to possess a definite aesthetic knowledge or taste, and he does not question the quality of the curio as a thing in itself. It merely serves to remind him (in many possible ways) of his experience in the national park in which he purchased it, and, what is most important, it serves as a reminder of the park itself, directly or indirectly as the case may be. . . .

It seems that in an earlier day, authentic relics of Indian Culture, real pieces of stone and petrified wood, scientifically accurate samples of rocks, bark, foliage, etc., were sought after by an

interested public. These things were *real* — they were an actual minute fraction of the environment — they made no pretense of being anything extraordinary — and there was no "commercial" motivation in their production (except, of course, they were usually sold at reasonable prices). As time progressed, the supply of natural legitimate objects was reduced in relation to the demand, and the commercial "souvenir" appeared. It is hard to say just when the "souvenir" business came into its own — probably it was an inevitable development of the "curiosities" marketed in country fairs and resorts. Once the commercial possibilities were discovered a large and profitable industry was established; *authenticity* was not included as a governing factor. . . .

There is another form of curio which has much less justification, especially for sale in the national parks. Commercial factories produce pennants, pillowcases, purses, bookmarks, paper knives and paper weights, dolls, etc., [marked with the name of the relevant] national park . . . "Sequoia Nat'l Park," and so on.

This type of curio is impossible to justify as an article for sale or distribution in any national park. The shops selling such "curios" cannot be blamed for depreciating the public taste and exploiting the parks. Nothing else exists for them to obtain and sell on a commercial scale, and few of the dealers have the taste, knowledge, or capital necessary to enter a special manufacturing field. And it is safe to assume that few have ever considered the principles underlying the social-cultural principles of the national parks, being occupied entirely with the attention to business along conventional patterns. . . .

The American public seems to have acquired the curio habit, and probably would not understand the sudden removal of ordinary curios from the counters of the shops in their favorite resorts. To put in effect an immediate change of policy regarding the type of curios available in the national parks would produce hardship both on visitors and operators.

Deplorable as it is that no better material is available for public consumption, it is still more deplorable that the poorer type of material is so "popular" (meaning — that it sells fast at a high profit). And it is perfectly true that the public at large does not make active discrimination between "good" and "bad" material. Yet, "not knowing the difference" may mean "acceptance with what is presented." Discrimination exists in almost every class of people, but discrimination is often secondary in

the face of relatively low prices and availability. And, unless better quality material is produced in volume the price thereof is certain to be higher. The obvious answer is: good quality curio material in volume production. . . .

Of course, the major problem is where to turn for suitable material. The curios most logical for a California Park, for instance, would be as follows:

1. Useful articles in natural woods. Paper knives, paper weights, vases, ash trays.

2. Useful articles in natural rocks. Paper weights, carvings.

3. Collections of pressed leaves of local trees and plants.

4. Carvings and casts of local animals, birds and insects.

Merely licensing commercial factories to produce such material would not be satisfactory unless proper control was exercised. All such material should be designed, executed and supervised by competent artists and craftsmen. There are many fine artists and craftsmen now under WPA and Treasury Department patronage that could do a magnificent job in this field. For instance, a fine sculptor could design little figures of animals and birds, which, on park service approval, could be duplicated in quantity in appropriate materials. Descriptive booklets could be designed and compiled from the works of good painters and photographers, etchers and lithographers. And so on through the entire field of souvenirs. . . .

MEMORANDUM PRESENTED TO
PRESIDENT GERALD R. FORD, JANUARY 27, 1975:

NEW INITIATIVES FOR THE NATIONAL PARKS

1. Redefinition of the meaning of parks, and the basic purposes of the system.

2. A presidential Commission to thoroughly study and modernize the organization, personnel, and attitudes of the National Park System.

3. A major review of concessions policy and management, developing non-profit, public trustee foundations as the optimum approach to best serving the public and the parks.

4. Reduction of man's physical impact on prime areas such as Yosemite Valley and replacement of automobiles by alternative transportation systems in most parks and monuments.

5. New emphasis on preservation and environmental

responsibilities. Improved park interpretation, stressing natural values and contemporary awareness.

6. Improved National Park Service performance in realizing and expanding compliance with the Wilderness Act.

7. Urgent Presidential intervention to prevent any Office of Management and Budget reductions in proposed Park Service Budget and staffing levels.

8. Presidential level review of all areas of future park or reserve potential. This generation may have the last chance to save essential lands for future generations.

MEMORANDUM PRESENTED TO CECIL D. ANDRUS (SECRETARY OF INTERIOR), SEPTEMBER 27, 1977:

INITIATIVES FOR THE NATIONAL PARKS
I. A distinguished Commission, appointed by the Secretary, composed of non-Park Service personnel, with the following assignments:

1. To redefine and "re-energize" the meaning and purpose of the National Park System, including the development of the "Preserve" or "Reserve" concept.

2. To thoroughly study and modernize all aspects of the organization, structure, personnel & recruiting/training systems, as well as attitudes of the National Park Service.

3. To fundamentally review current concessions policy and management, with a view to developing non-profit, public trustee foundations as the optimum approach to best serving the public and preserving the Parks.

4. To review all possible and potential areas in the United States for present or future consideration as units of the National Park system.

II. Vigorous Pursuit of the Historic Opportunities now before us in Alaska. Support of the Andrus proposals as a minimum, and the Udall proposals as most desirable.

III. Immediate Initiatives on major new or expanded areas:
 1. Redwoods (support Administration proposal)
 2. A Big Sur National Preserve
 3. A Sawtooth National Reserve
 4. Add Mineral King to Sequoia/Kings Canyon

5. A White Mountain National Reserve (N.H. & Maine)
6. An Appalachian National Park
7. Expand Death Valley and change from Monument to Reserve or Park status
8. Change Glacier Bay from Monument to Reserve or Park
9. Cumberland Island

FROM "GIVE NATURE TIME,"(COMMENCEMENT ADDRESS, OCCIDENTAL COLLEGE), 1961:

I support a positive philosophy of life and art. Wherever this leads me, I am sure it is further than were I a practicing pessimist! I frankly profess a somewhat mystical concept of nature; I believe the world is incomprehensibly beautiful — an endless prospect of magic and wonder. Whatever mess we observe is our own responsibility! In general, man has always struggled toward objective excellence and now that some knowledgeable means of achieving it are in his grasp, he may succeed with glory or fail with catastrophe. I remain an optimist and I believe man will, in the end — and on this earth — succeed with glory. . . .

I now venture a few leading statements: one, that there is a profound difference between recreation and *re*-creation and that the experience of nature relates to the latter through what the great National Parks and Wilderness Areas offer us; two, that art is about the only way to bring about an adequate and exciting contact between the realities of society and the implications and potentials of nature; and, three, that man must be guided, not driven, to the appropriate and effective relationship with the world in which he lives. . . .

I salute the lumber industry for its development of recreational facilities in second-growth forests, but I protest its opposition to the establishment of a great Redwood National Park wherein only the intangibles — the primal qualities of the natural scene — can be appropriately experienced. The appreciation of the natural scene should not be limited only to the grandeurs; the intimate details and qualities of our immediate environment can be revealed and appreciated. To protect these qualities will require a new planning approach of the highest order of sensitivity and effectiveness. We are prone to think of natural beauty — parks, reserves, "dedicated areas," etc. — in

terms of locations on maps, restricted by borders and boundaries and viewed "vertically." This pseudo-aerial view can be misleading; our vision is usually projected *horizontally* and the vistas of the world are as important as the actual contact with rock and soil and growing things. Hence, the *prospects*, the glades, the lines of the hills, and the vast expanses of shore and ocean, these too must be preserved. . . .

We must take ALL resources under consideration; *all* resources, because they relate fatefully to our life on earth, reflect certain grandeurs, and deserve not only our attention, but our reverence.

Hence, while it is as essential as ever to protect the National Parks and the Wilderness Areas, it is also essential that we protect the forests, the crops, the minerals and the oceans, and it is essential that we preserve the purity of the air we breathe and the water we drink. Certainly with the technology now available, air and water pollution could be severely reduced if not arrested completely and fully controlled. It is ridiculous to quibble about costs in this regard; the ultimate cost of pollution can be the destruction and death of plants, animals and people. . . .

Clarification, not mere euphoria, is required if we are to succeed. We will have to recognize the oneness of all resources — the economic, the recreational and the spiritual qualities and potentials of the world. The principle of "multiple use" — strongly supported by the United States Forest Service — can, in my opinion, be applied to the first two categories, but not to the third category, represented by the National Parks and the great Wilderness Areas. Unfortunately, recreation and *re*-creation are not sufficiently differentiated to stabilize the policies and decisions of most government and enterprise groups.

There is a constant erosion of the concept and the reality of wilderness. The luxuries of modern life — motorboats, proliferating automobiles, portable radios and television sets — all the comforts of urban shelter transported to the wild places on roads built primarily for this purpose — such as these have served to make mass recreation a very profitable enterprise.

There is certainly nothing amiss with camping, fishing, boating, swimming, skiing and all the other participation and non-participation sports; people do not have enough of these healthful and refreshing experiences. But you do not play ping-pong in a cathedral, rustle popcorn at a string-quartet concert or hang billboards on the face of Half Dome in Yosemite (not all of us would, anyway!).

You must have certain noble areas of the world left in as close-to-primal condition as possible. You must have quietness and a certain amount of solitude. You must be able to touch the living rock, drink the pure waters, scan the great vistas, sleep under the stars and awaken to the cool dawn wind. Such experiences are the heritage of all people.

It is naive to believe that such priceless amenities can be legislated into being and protected for all time. I must remind you that the National parks exist because of an Act of Congress; this Act could be altered or repealed at any time if the clear majority of our people so desired. In fact, proposals have been made, seriously, to put all Federal Lands under the control of the nearest township, or to sell off all Federal lands to the highest bidder. Surely, this is a most remote possibility; it is not probable, but possible! The continued invasions of roads in the wild areas *are* probable, the gradual destruction of the beauty and intimacy of high-mountain meadows, through over-use, *is* probable. Highly probable also, is the total pollution of our air and water, and the building of extensive urban and suburban "developments" — which can change in time to ghettos or to slums.

To man's technical ingenuity almost everything is possible; to control the probabilities will require another ingenuity, a fresh attitude of respect for, and love of, the land. The reclamationists and the developers speak of the conservationists' "unreality," not realizing there are other realities, other objectives, other accomplishments in the life of man than the poorly modulated technological and economic achievements of our nervous time. . . .

LETTER TO PRESIDENT JIMMY CARTER, JULY 16, 1980:

. . . I am well aware of the political problems involved in the Alaska situation. We can become believers in greed, selfishness, and lack of concern, as representing the opposition, while belief in nature, disinterest in the profit-motive and a quasi-religious sacrificial attitude justifies the environmental approach. It is not that simple! Harold Ickes ordered that the term "values" not be used in description of National Park qualities. He felt the concept of parks, wilderness, preservation, and protection were not matters of "values" but of dedication to ideal concepts relating

to the general, ultimate good of mankind. This philosophy has been important to me; I think I understand it.

In the struggle we have had for the Big Sur National Scenic Area, I find that many people living there love the place and would not wish to harm it; they would not build a road or a house, *but they demand the right to do so*. Their egos are disturbed, not necessarily their ethic. They become very vocal; they oppose the "Feds" as a matter of principle. They have no concept of how helpful the "Feds" (in various forms) have been, and will be. Mistakes have been made — sometimes serious ones — but in the end, we are a Federalist nation and it is ridiculous to think of our existing without respect and confidence in our federal institutions. . . .

The threat of the Soviet (Marxist-Leninist) philosophy is very real. As I have often asked, "How many people in Congress or other levels of government have read the basic Marxian philosophy and studied the variations of the Leninist, Trotskyist, and Maoist approaches?" The Afghanistan episode is "just as expected." Iran will be next, West Germany, and the NATO countries could follow. Who is going to first press the fatal button?

Why should we worry about Alaska or any idealistic concepts of the natural scene and wilderness if we are engulfed with such world threats? Perhaps, in a very few years, all such adventures of the human soul and mind may have come to naught. However, perhaps these idealistic concepts (just as devotion to the arts and sciences) will serve as the restraining influence against total destruction. People should be reminded in no uncertain terms that all they have been trained to live for and believe in might be extinguished in a moment of time. I do not think people are aware of the true situation. It should be built into the consciousness of everyone in the world that a nuclear war would extinguish all peoples and all cultures.

The preservation of Alaska is *symbolic* of hope for their future. The preservation of all resources, tangible and intangible, in all continents, is obviously essential for the future. Wilderness is but one facet of the jewel of civilization. It can be tied in with the benefits of a functioning society; it has the advantage of relating to visible and tangible experiences.

You, as our President, have the great — and quite possibly — *the only* chance to clarify this enormous problem.

May God go with you.